THE HIMALAYA

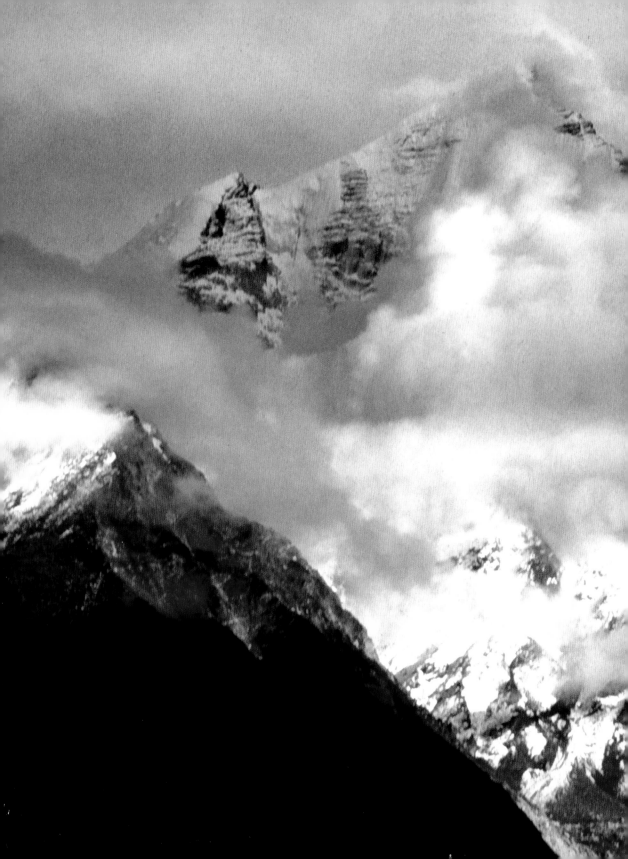

THE HIMALAYA

Encounters with the Roof of the World

BY DAVID ZURICK

Center Books on the International Scene
George F. Thompson, series founder and director

The Center for American Places
at Columbia College Chicago

Published in 2011.
Printed in China on acid-free paper.

The Center for American Places at Columbia College Chicago
600 South Michigan Avenue
Chicago, Illinois 60605-1996, U.S.A.
www.americanplaces.org

18 17 16 15 14 13 12 11 10 1 2 3 4 5

Library of Congress Cataloging-in-Publication Data
Zurick, David.
 The Himalaya : encounters with the roof of the world / by David Zurick.
 p. cm. -- (Center books on the international scene ; 6)
 Includes bibliographical references and index.
 ISBN 978-1-930066-96-0 (alk. paper)
 1. Himalaya Mountains--Description and travel. 2. Himalaya Mountains--Geography. 3. Himalaya Mountains Region--Description and travel. 4. Zurick, David--Travel--Himalaya Mountains Region. 5. Himalaya Mountains Region--Social life and customs. I. Title. II. Series.

 DS485.H6Z86 2010
 915.49604--dc22

 2010015795

ISBN 978-1-930066-96-0

Frontispiece: Bhagirathi Peak II in India, 2004. Photograph by David Zurick.

1408

CONTENTS

I embarked on a journey in 1975 that took me from my home in Michigan to Europe and then across Asia to the Himalaya, where I discovered a region of glistening mountains and a land of burgeoning cities and stone-and-timber villages. The place impressed itself upon my geographical imagination, such that I've worked hard ever since to return there as often as possible. Over time I was able to parlay my fascination with the Himalaya into a career as a geographer. During the past three and a half decades, in the course of numerous excursions, I've walked thousands of kilometers and miles through the mountains and covered even greater distances by bus, jeep, horse, yak caravan, and motorcycle. These journeys have guided me into some of the most exquisite places on Earth.

I always mix work and pleasure when I'm in the Himalaya; indeed, the two have become inseparable, and that is one of the great joys of my life. The essays that appear in this book stem from experiences I've had while conducting my studies in the mountains. A few of them deal with topics I've addressed elsewhere in the scholarly literature in which I use the conventions of academic language. Here, I put my thoughts down in plain English. With these essays, I seek to evoke rather than to explain a part of the world that is one of its most spectacular, filled with extraordinary places and people and turbulent in the currents of modern life. I consider not simply the physical presence of the Himalaya, however majestic that may be, nor even its rich display of human culture, but rather how it occupies our thoughts.

I take measures when I'm in the Himalaya to center myself within it. That's a highly subjective endeavor. Academic inquiry, on the other hand, strives toward an intellectual objectivity by creating a distance of separation, which isn't entirely compatible with my goals; and I have no real interest in disassociating myself from the world I seek to understand, as if that, indeed, were possible. The scholarly approach, with its concentration and focus, has served me well in my past work, and geography continues to guide my work in the Himalaya, but it tends now to be construed in emotive ways that stretch the boundaries of scientific reason. I'm not concerned here so much with the geographical facts of the Himalaya as with my own appraisal of them. This necessarily entails a subjective inquiry, which is, admittedly, in my case, a foreigner's perspective that changes with knowledge, experience, outlook and insight.

The themes in this book—enduring places of purpose and imagination, inroads of modernity, environmental circumstance, and cultural identity, among others—follow no particular logic in the sense of an established academic theory or intellectual argument. And, to be sure, the book does not pretend to offer comprehensive coverage of the region, as one might expect of a textbook or even a guidebook. Rather, the essays (and my photographs) are a distillation of my own geographical encounters with the Himalaya during the past thirty-five years, and they are meant to appear like beads on a necklace, each singular in effect but contributing to a whole. It's a matter of synchronicity that my time spent in the Himalaya coincides more or less with a great turning of events there, so that many of the essays embrace the idea of change, both within the mountain worlds and in my own appraisals of them.

The essays, furthermore, roam widely across the Himalaya and thus sketch no formal or overarching structure of the mountains and the lands and life therein. It may be helpful for the reader to refer to other books for that purpose, many of which appear in the *Recommended Readings* section at the end of this book. By way of reference, though, the essays are geographically grounded.

Kathmandu is the subject of the first essay. It's the capital city of Nepal, located in the central Himalaya, and it is known in both the colonial literature and contemporary tourism brochures as the exotic gateway into the Himalaya. Indeed, there is much to be said about Kathmandu being both gateway and

exotica. The Buddhist and Hindu worlds of Asia converge in Nepal, among numerous cultural traditions, and they are distilled in the urban landscape of Kathmandu. For most visitors to the Himalaya, Kathmandu is their point of entry and the place where they first confront the Himalaya's stunning physical and cultural attributes. The mountains that overlook the Kathmandu Valley are among the world's highest, and Nepal itself claims eight of Earth's peaks higher than 8,000 meters (26,247 feet); of the remaining five, four are located in the Karakoram Range in Pakistan, and one is in Tibet.

In the second essay, "Tethys Rising," I explore the geological structure of the 2,700-kilometer-long (1,700-mile-long) Himalaya by way of the western sectors of Ladakh, Zanzkar, and the Baspa Valley. There is good reason for this. These areas define the western geological boundary of the Himalaya, where the mountains follow the Indus Valley in proximity of Mount Nanga Parbat. North and west of here is Pakistan's Karakoram Range. The trans-Himalayan valleys of Ladakh and Zanzkar lie beyond the main reach of the summer monsoon and appear as deserts with little vegetation cover. Their exposed strata illuminate much of the 60,000,000-year-old tectonic history of the Himalaya. A profile drawn from the northern ranges of Ladakh through Zanzkar to the Baspa Valley captures much of the complexity of the Himalaya's geological extrusion.

Traditional life in the Himalaya is rigorous and greatly nuanced, and it is the subject of the third essay, "Life in the Balance." For a year I lived in the small village of Phalabang, in western Nepal, where I participated in the world of Hindu farmers, who live in accordance with the natural contours of the mountains. It was there I sought to understand the exacting terms of their lives. The intense vertical outlook of the Himalaya challenges villagers with a diverse topographical setting—from high mountain pastures to subtropical plains, which they use to their advantage in various farming, herding, and trading practices. The summer monsoon, furthermore, introduces a seasonal rhythm to life in the Himalayan villages and greatly influences the fertility of the land and its biological diversity. Villagers negotiate the environmental conditions with a rich repertory of knowledge, beliefs, and customs.

Phalabang is located in an alpine zone known as the middle mountains. This zone, which ranges from 1,700 to 2,500 meters (5,000 to 8,000 feet) in elevation, hosts the vast majority of the 50,000,000 people who live in the

Himalaya. I would say that life in Phalabang is fairly typical of mid-elevation village society across much of the range, where people adjust to the changing circumstances of their lives in ways that make the most sense to them, in accord with their unique traditions and also with an eye toward the future.

In the fourth and fifth essays, I introduce very specific and different ideas about economic and social change in the Himalaya. Bhutan, the subject of the fourth essay, "In Pursuit of Happiness" is a Buddhist kingdom that has embraced a unique approach toward development by zeroing in on the notion of happiness. The king of Bhutan proposed during the 1980s that the Buddhist ethics which govern Bhutanese culture should be the template for determining the course of societal change. His so-called "Gross National Happiness" policy attempts to chart the success of national development by calculating the cultural and environmental determinants of a person's happiness. It's a tricky matter for a nation to measure happiness, much less to foster its acquisition, and not everyone in the kingdom is happy. The rigid structure of Bhutanese society, with its hierarchy of noblemen and religious figures, and the exclusion of non-Buddhist ethnic peoples from the mainstream of social development challenge the king's quest for a nation of happy citizens. Nonetheless, Bhutan provides a unique alternative to the normal assessments of social change in the Himalaya, and it offers important lessons about managing natural and cultural environments.

Unlike Bhutan, which strives to control the terms of its future, however fragile a proposition that may be, the easternmost region of the Himalaya, located on the frontier of Tibet, has all but relinquished its destiny to a commercial fabrication imposed by Chinese planners. That is the subject of the fifth essay, "Shangri La." Curiously, the Chinese have made a calculated determination: the mountains of eastern Tibet (Kham) and adjoining regions of Yunnan and Sichuan provinces are the mythological home-ground of paradise—or, more precisely in the case of the Himalaya, Shangri La. The term "Shangri La" was coined by James Hilton in *Lost Horizon* (1933) to denote a fabled land of antiquity, where people grew very old in peace and abundance. It has since entered the Western lexicon alongside Sir Thomas More's popular conception of "Utopia" (which dates much earlier to 1516) to describe an imaginary and idealized world. With the dawn of the twenty-first century, China's economic planners embarked on an ambitious plan to appropriate the key features of the region's natural and cultural heritages and to develop

them as tourist destinations. As a result, much of the eastern Himalaya has become an awkward transfiguration of Hilton's mythological landscape.

Those who know the Himalaya might observe and even argue persuasively that the easternmost ranges of Tibet and the adjoining Chinese provinces lie outside the geographical purview of the Himalaya. Indeed, the mountains here are bisected by the great gorges of the Yangtze, Salween, and Mekong rivers, so that the Hengduan Range, which rises majestically above them, appears distinct from the rest of the Himalaya. A strict geological interpretation of the Himalaya would support that viewpoint. If you ask the people who reside in the region where they live, however, most would reply "the Himalaya," pointing to longstanding patterns of trade, migration, and pilgrimage as well as to climate and topographical alignments, to support their view. I accept this fairly liberal geographical interpretation when I include eastern Tibet in this set of essays about the Himalaya.

I have always intended this book to be highly personal in both content and encounter. Thus, I conclude with a brief sixth essay, "Encounters with the Himalaya," which allows me to reflect upon my years there. I have posted on my office door at the university where I teach a note for my students, which reads: "The idea is not so much to see different places as to see places differently." I can't remember where I lifted that quotation, nor have I necessarily replicated it exactly. But it does get to the heart of the matter.

The Himalaya has provided me not only with a spectacular place to live and work over the years, but also with cause to grow and to learn and thus to change and become the person I am. This book is an attempt to come clean with that proposition and to situate my work, at least partially, in the realm of the geographical imagination.

The maps and images we hold in our minds of places both near and distant, familiar and unfamiliar, allow us to make sense of the world, of our place in it, and the designs we impose upon it. My time in the Himalaya has given me the chance to enrich my life in the ways of adventure and knowledge, deepen my own thoughts about the region, and to know it in ways that now transcend my early scholarly appraisals. I hadn't fully realized all of that as a young geographer just embarking upon an academic career, but, in retrospect, it was the thing I had in the back of my mind from the earliest days.

THE HIMALAYA

KATHMANDU

(Kathmandu Valley, Nepal: 1975–2010)

O N ONE OF MY EARLY TRIPS TO ASIA, I flew from Bangkok to Kathmandu. My flight passed over the Bay of Bengal, and shortly thereafter I watched out the window as a low rise of mountains took shape on the northern horizon. It was the end of the summer monsoon season, and humidity filled the air above the Indian plains, obscuring the range so that I saw only a bluish smudge of relief where it stood against the sky. As we got closer, though, the giant snow peaks materialized—Kanchendzonga, Makalu, Everest, Cho Oyu, and Annapurna—like a row of tiny sharp white teeth. They floated magically above the haze, ephemeral, as if at any moment they might dissolve into it.

The summits imperceptibly grew in size as we approached, until we were right on top of them. Then the atmosphere suddenly cleared, and all at once we were flying among the mountains rather than toward them, moving through them. The very density of the air seemed to lighten. Rivers sparkled below me like wet snakes in the receding mist, and the emerald landscape became, in turn, menacing or jewel-like with its sharp relief and the cascading farm terraces.

The terrain contorted like a concertina beneath the towering white summits, which now appeared impossibly high and dangerously close. A valley plunged steeply into a vertiginous abyss, where the plane crossed a ridge. Pockets of rising air caused the aircraft to lift and drop precipitously, so that we bounced and lurched our way into the Himalaya amid thickening clouds. The land showed only here and there, teasing, lit by shafts of sunlight that pieced the clouds, hinting at the secret things below us.

The ground rushed toward us as we neared Kathmandu and began our descent. The last big hurdle to the south of the city is a summit called Pulchowki. It's dotted with monasteries, caves, and sanctuaries where pilgrims have long taken refuge from the city. We flew low over the promontory, jostled by air currents, within reach, it seemed, of the upper branches of the forest canopy. An ancient stone and brick temple, dripping with moss, stood among the trees like a wizened beacon for the pilots to use as a navigational aid on the final approach to the airport.

The turbulence ended when we cleared the ridgeline and settled into the sky above the Kathmandu Valley. The plane then swept smoothly over a cultivated scene of temples and farms.

It was a splendid sight flying into the valley. It appeared as if little had changed during the preceding centuries, and the colorful history of the kingdom was evident in the landscape below. Traditional features still dominated the scene: Stucco-and-thatch farmhouses, grain fields, cattle in pasture, meandering rivers and farm lanes that intersected according to the lay of the land, spiraling rooftops and ornate facades of imposing monasteries, all composing, like the pieces of a puzzle, an imaginary and far-off place. Prayer flags fluttered wildly above a golden temple, so that it appeared to be caught momentarily in flight. A medieval town, surrounded by rice paddies whose watery surfaces caught the sky and passing white clouds, appeared to float in a lymphatic prism. Plumes of smoke hovered above cremation grounds before drifting toward a bamboo grove that encircled the king's palace.

The passengers seated around me in the plane, relaxed now that we had safely cleared the southern mountains, shared my enthusiasm for the sights of the valley. They exclaimed in various languages and gestured out the windows at the cultural monuments, which popped into view, one by one, as if cut from the illustrated pages of a storybook. In the background were the icy peaks.

Such fanciful images of the Himalaya are pleasing and self-evident and a delightful abstraction, but they don't, of course, fully describe the place; they're rendered, after all, from the view out the window of a passing jet airliner. My later explorations sketch more complex pictures of the mountains, showing them to be places of struggle, contradiction, and change as well as

of harmony and timelessness, degradation and beauty; a place, after all, of human circumstance. Nonetheless, I retain in my mind that initial bird's-eye view of the Kathmandu Valley—its luminous qualities laid the foundation for much of my later inquiry into the nature of life in the Himalaya, encouraging me not merely to observe and document, but to imagine the place.

The scale of the mountains is enormous, and their scenery is spectacular. For once, the glowing superlatives used to describe a place are entirely appropriate. The Himalaya contains Earth's highest mountain (Mount Everest: 8,850 meters; 29,035 feet), deepest gorge (Yarlung Tsangpo Gorge: 5,382 meters; 17,657 feet), and wettest place (Cherapunji: 10,871 mm/year; 427 inches/year). It's a trove of natural wealth, with more than 10,000 native plant and animal species and a biodiversity center of global significance. Caught in its altitudinal grasp is a plethora of climates so diverse that a flatland equivalent would require traveling across the planet's surface from tropical to polar latitudes. Geography thus bestows upon the Himalaya an extraordinary presence.

Such attributes taken alone, though, might threaten to reduce the Himalaya to a geographical oddity, as if its profuse qualities are merely a hyper-attenuated architectural feature of the planet's surface, were it not for the story of humankind in the mountains. In fact, the rugged setting is most extraordinary precisely because it has been settled by people for so many generations. Today, more than 50,000,000 people live in the Himalaya and contribute enormous human prospect to it. Their settlements have altered the very shape of the land, and their societies weave an astonishingly rich fabric of life that drapes the mountains in the shimmering folds of tenacity and enduring human purpose.

The Himalayan natives find their origins either in the great civilizations of India and Tibet or among tribal lineages extending from the deserts of Central Asia to Burma's wet jungles. They migrated to the mountains as early as the Neolithic and then later with the Aryans sometime between 1500 and 1000 B.C.E. (Before the Current Era), continuing through the medieval period, first with migrations from Rajasthan in India and later from Tibet. This vast geographical underpinning helps to explain the cultural wealth of the Himalaya—its widely revered customs and beliefs and a multitude of

languages, lifeways, and architectures. The diverse cultures exhibit a profound attention to the land, overlain by successive generations, which, in the course of adapting to the mountain worlds, have forged some of the most arresting societies and landscapes in the world. Indeed, the assembly of people and their imprint on the terrain of the Himalaya is every bit as impressive as its physical structure.

Cultural miscegenation greeted me when I disembarked from my flight to Kathmandu. The normal chaos of international arrival—with its attendant paperwork, customs clearance, baggage check, among other things—was further confused in the polyglot airport, where information signs appeared in multiple languages, and the staff tried to guess the nationality of visitors by first speaking any number of European or Asian dialects before finally settling upon English. In addition to the international tourists, a parade of Himalayan tribes milled about—Gurungs, Magars, and Thakalis from the Annapurna and Dhaulagiri ranges, Sherpas from the Khumbu region below Mount Everest, Tamangs from the central Trishuli River ranges and Langtang Valley, all jostling for the attentions of the airport officials, travelers, and one another. The swirling crowd was boisterous and unkempt and lent a colorful, carnival-like atmosphere to the airport lobby.

I made my way outside and through a phalanx of hucksters to a taxi. The road from the airport into town navigated alleyways and open-air markets teeming with pedestrians and rickshaws, traversed by desultory cattle, and lined with a medley of tiny shops offering dry goods and all manner of services—to Byzantine effect. What had appeared orderly from the sky was chaotic on the ground.

The city lacked adequate infrastructure. The roads were narrow and rutted and meandered endlessly en route to their destinations. Ancient brick and timber homes stood amid modern, box-like, concrete structures. Power lines spanned the distances between houses in a spidery web of unregulated and dangerous electricity. The traffic on the busy streets appeared random, guided by bells, blaring horns, whistles, and shouts rather than by actual driving regulations. Cows had the same right-of-way as automobiles, and both gave way frantically to the lumbering buses and trucks that belched acrid black diesel smoke.

My driver's name was Joshi, and he wove crazily through the urban chaos. When I asked him to slow down, he shook his head and instead revved the engine, honked, and darted through the gaps that quickly opened and closed in the traffic.

In its confusion, Kathmandu resembles other Asian cities similarly caught between tradition and the crush of modernity. Time is compressed in such places, and the future seems ready to devour history by making it obsolete. In 1975, when I was first becoming familiar with the city, global events barely touched upon its features; nowadays, they threaten to bury its past. The cultural monuments I observed on early visits—hand-built homes tottering around ancient stone courtyards, Buddhist sculptures set amid Hindu pagodas, tiny bazaars packed with spices and textiles and emitting the rich and musty scents of ripe produce, incense, and cattle dung—all still exist, but they are harder to find beneath the weight of the modern accretions.

The cobblestone roads are covered now in thin sheets of asphalt, and multi-story buildings topped with rusting spikes of rebar (presaging yet another level to an already flimsy structure) overshadow the vernacular architecture. Piles of household waste line the back alleys. Smog and dust obscure the mountains much of the time and are hazardous enough on the bad days that people wear white cotton masks over their mouths and noses. They look like bicycling bandits or health workers scurrying about in the midst of an epidemic. The din of traffic sustains a crescendo, and the cattle which still scavenge in the streets must contend with faster vehicles and less patient drivers. Civil unrest, corruption, armed insurgency, a failed democracy, and a despotic king have all stood in the way of progress, and the city has suffered greatly from their excesses.

Visitors arriving now in Kathmandu fly over a valley that looks very different from the one I had encountered many years ago. The city has spilled over its medieval boundaries and sprawls muscularly across the valley floor. The farmland, some of the richest in the kingdom, is covered now in a hodge-podge of industrial features and homes, so that it has lost much of its organic sense. People fleeing the rural villages each year push Kathmandu further onto the countryside. The city is climbing the hills. Meanwhile, the open

spaces that once existed within Kathmandu and gave it breathing room—the courtyards, temple grounds, and gardens—are filling in as well, adding to the congestion and diminishing a traditional sense of place.

Nonetheless, despite these clumsy and rather prosaic new arrangements, Kathmandu manages to retain an enduring sense of the mystique. It still serves as the primary gateway into the high Himalaya, whose summits overlook the city and remind people of where they are in the world. Poking here and there into the sky are the old temples, glistening and oddly shaped, hinting at the pulchritude that lies beneath the hubris of the city's new identity. The mixture of races and tongues and the traditional attire of the townsfolk lend an exotic aspect to the city's streets and marketplaces, even if they now are given over almost exclusively to the barter of global goods. The old sections of the city, meanwhile, remain much as before: intimate and hidden behind high walls, with low-slung doors opening onto sequestered neighborhood courtyards. It's for the sake of the historical landmarks, rather than any claim on postmodern urban sensibilities, that Kathmandu continues to attract people from around the world.

After navigating from the airport to the center of town, Joshi deposited me at my lodging. At that time hotels were few in number, and the small guesthouses were simple affairs. I had selected a small lodge popular with mountain climbers and scholars, taking a room on an upper floor, which opened onto a rooftop with views of the city, valley, and the snow peaks that outlined the northern horizon. Kathmandu then did not suffer the air pollution which now plagues it, and the mountains appeared at arms-length in the clear air. It was a relief to sit in the potted garden on the roof of the inn and take in the views. The afternoon skies were filled with clouds adrift in a dazzling blue space hemmed in by the mountains. In the evenings, a dim alpenglow lit the summits, firing them with deep shades of red, while the streets flickered in the yellow light of lanterns and cooking fires.

I made arrangements with Joshi to pick me up on a following day for an excursion to the rim of the valley. He was waiting for me early on the appointed date. I explained that I was in no hurry and wanted to see something of the land and stop at the important cultural sites. He agreed. It took only a few minutes to leave the city, and soon we drove past farmhouses,

through quaint towns, across cobblestone bridges, and among ripening grain fields. The land rose gently toward the eastern hills, green and fecund. Our route meandered through the scene I'd observed a few days earlier from the sky and, unlike the city center, showed the quiet charm I had imagined when I sat in the plane and looked down upon the valley.

When I asked Joshi about his background, he said that he was from a village located a three-day walk north of the valley and pointed out the window toward a high ridge dusted in snow, beyond which lies his village. He told me that he'd been living and working in the city for almost ten years, since he was twenty-two years old, and that he was raising his family there.

I pressed Joshi for additional details about his mountain home. He was reluctant to speak of it, wanting to talk instead about his life in the city: new friends and amusements, opportunities to make money, the tiny, two-room concrete apartment where he lived with his wife and two children who attended an English medium school. A decade ago the man had left a failing farm in the hills to labor in the city; now he was a taxi driver, and, to that effect, he had made good progress. He looked back at me through the rear-view mirror and gamely said he'd rather look to the future than think of the past.

Yet, as we gained distance from Kathmandu and drove further into the countryside, our conversation slowly turned away from events in the city and onto the surrounding scene, and Joshi's remarks, in turn, began to center back upon his village. It was as if, in crossing the distance from city to the valley farms, he had returned to his rural self; his voice even lost some of its urban bravado. He compared the fertile fields to the thin mountain soils he had farmed as a boy, pointed at livestock, noted the breed of an animal and whether or not it could be found in his village, and remarked on the vitality of crops in a field, suggesting ways a farmer might improve them. He seemed eager to display his knowledge about farming once we'd left the city, as he'd been to recount metropolitan life while we were still in it.

Whenever we passed a shrine beside the road—and there were a great many of them—Joshi would absently raise his hand to his forehead and mumble a quick prayer. For that moment he seemed transfixed, but then quickly he'd return to the task of maneuvering his vehicle on the narrow country road: bypassing women combing their wet hair at a roadside water faucet,

swerving at the last moment to avoid crashing into a motorbike, honking at pedestrians, cows, and bicyclists, skirting deep craters in the road. He flashed me a wide grin as if to say he was having fun.

I asked Joshi if he missed his village. He said he did but that he hardly ever visited there; only on special religious days would he make the journey back home. On those rare occasions, he visited the family temple with his parents to conduct the ancient rituals, feasted with relatives, and hung out with the friends who'd remained behind in the village. He wistfully recalled those visits, how the days passed slowly as he lounged and played cards, sometimes helping with the farm work or walking in the countryside with old school chums. He remarked that his life was different in the city—much busier, and, despite the crowds, lonelier. Joshi's demeanor struck me as typical of the mountain villagers I've met over the years—gentle, respectful, and a bit reticent. Although he resided now in Kathmandu and had made the city his home, it was clear he hadn't altogether relinquished his village personality. As he explained, the city allowed him a more prosperous outlook, but, even so, his reminiscence back-pedaled to his life in the mountains.

As we progressed across the valley floor, Joshi pointed out religious sites and recorded their history, suggesting how this or that place was powerful because one or another great deity had visited there. In some spots, a temple or shrine had been erected, often atop a hill or to enclose a sacred spring or tree or rock. He said the mountains above his village also were filled with holy places where saints had lived and that, as a boy, he had visited many of them. He confessed that, although such matters mean little to his urban friends, he still looks to the mountains for a sense of his past and finds assurance in it. If things fall apart in the city, he can always return to his ancestral village.

When in the Himalaya it's common for one's thoughts to move beyond the appearance of the landscape into a world of contemplation. In part, that is because its geography is so carefully delineated in what I call the "sacred calculation" of land. The Western abstractions of space—straight lines, Cartesian grids, and right angles, which futilely proclaim human dominion over it—give way in the Himalaya to a more reverential organization. The ancient tantric traditions of Buddhism and Hinduism imbue the mountains with sanctity,

among the holy places of pilgrimage, at the numerous religious monuments that mark the landscape, and for the large numbers of faithful who find in them reasons for devotion. The chanting monks and priests, the steady slap of a porter's bare feet on a mountain trail, or the quiet, melodious conversation of herders huddled around a juniper fire under cold stars all suggest an accord with larger, cosmic sketches of time and space.

One need not go very far into the Himalaya to discover such religious sentiment. A deep calm is found even in large towns such as Kathmandu—amid the ringing and honking and shouting of an intersection, when an ashen sadhu in loincloth, lost in apparent thought and with bright eyes, suddenly appears out of nowhere. He walks by, navigating effortlessly through the crowd, going unnoticed despite his outlandish appearance, as if an apparition or simply a passing wave of energy. At countless shrines tucked into alleys or hidden beneath giant trees, townsmen on their way to work or shop will stop and pay quiet homage to neighborhood deities with bowed heads, clasped hands, and the steady ringing of temple bells.

Kathmandu is filled with pilgrims and wandering holy men. Many of them come from India specifically to visit the Pashupatinath Temple, which is devoted to Shiva—the god of dissolution and rebirth who took up residence in a forest above the ancient city. Hindu mythology tells how the great deities pleaded with Shiva to return to the holy mountain of Kailas in western Tibet, where his supernatural origins lie, but he refused to leave his sacred grove in Kathmandu. Pilgrims visit the shrine to pay homage to Shiva. They gain purity by bathing in the tepid waters of the Bagmati River, which flow past the temple's cremation pyres, where the bodies of the faithful burn amid flaming heaps of wood and hope.

From Tibet the pilgrims come to Kathmandu in order to circumambulate the famous Buddhist monasteries at Swayambunath and Bodhnath. The Swayambunath shrine dates to the fifth century B.C.E. and occupies a spot on a hill, where legend proclaims a celestial lotus once blossomed in a sacred lake. The shrine is protected by a battalion of bronze thunderbolts, meditating plaster Buddhas, stone serpents, a 365-step rock staircase imprinted with the foot marks of Buddha, and a platoon of aggressive macaque monkeys. Across town from Swayambunath is the central stupa at Bodhnath. It's one of the

world's greatest Buddhist shrines—an immense, spiraling dome with painted eyes that gaze onto the valley in all four cardinal directions.

The Buddhist pilgrims walk clockwise around the Swayambunath and Bodhnath stupas, spinning prayer wheels, praying, chanting, and counting beads. They light incense and burn oil in little brass lamps tucked away in stone alcoves and courtyards. The most devout among them make their way around the temples by full-length prostrations, falling to the ground with outstretched arms and pulling themselves forward in body lengths. Their slow progress around the temples stirs up dust that sparkles in the sun like tiny flecks of gold, haloing their robes and faces that are smeared in tallow and dirt.

Throughout the Kathmandu Valley—from Ichangu Narayan in the west to Vajrayogini in the east, at Swayambunath and Bodhnath, among the bloodied altars of the Dakshinkali Temple, where animals are sacrificed to placate the wrathful Kali deity, and at countless other shrines along the way—pilgrims mark their journeys with unflagging devotion, as they do across the vast spaces of the Himalaya. The propitiations of saints, sinners seeking redemption, women desiring children, children and elderly honoring ancestors, monks and priests chanting, the dying and infirmed praying, the demented and wise contemplating—they all delimit a sacred realm for people who seek in their journeys a way deeper into the mind.

It's an ancient quest, prescribed in the *Mahabharata* for Hindus and expounded in the esoteric texts of Tibetan Buddhism, such as those famously compiled during the nineteenth century by the Khampa pilgrim, Jamyang Keyentse Wangpo. These literary allusions shape an arcane geography of the holy Himalaya, draw upon oral histories, mythologies, and esoteric learning, and spawn a legion of treasure-seekers, known as tertons, who travel widely in the Himalaya in efforts to discover its spiritual secrets. Kathmandu figures prominently in the pilgrims' travel itineraries.

The physical destination of religious devotion may be a cave or a summit, the source of a sacred river, hot springs, a forest grove, or any number of other natural sites. Often these are embellished with sculptures, rock cairns, flags, or mossy shrines that mark the spot. Such places lie at the conjunction of belief and space. Journeying to them may be arduous, challenged by the vagaries of nature and human consciousness as much as by their cartographic

ambiguity, or they may lie within easy reach. Many such spots, for example, are located among the streets of Kathmandu. The intention of the people who visit them is to find a supernatural place in the landscape, one that may have no precise location on a map but which, nonetheless, can still be found.

Geography and religion thus meet squarely in the Kathmandu Valley and among the high peaks that surround it, in caves and remote gorges, along the banks of sacred rivers, and on the trails that lead pilgrims along journeys of hope and spiritual reconciliation. To acknowledge this convergence of topography and belief is not to romanticize or exaggerate the Himalaya's mythological terrain but simply to understand its role in the history of humankind's quest for enlightenment and salvation.

As it turns out, the mountains provide more than spiritual solace; they hold the resources that make life possible for those who live among them: water, soil, plants, and minerals. That sustenance, though, is not easily obtained. It requires that people cope with the difficult land by understanding it well. Accordingly, villagers have put the mountains to remarkable use. They literally carve their lives into them, sculpting the hillsides into terraced fields of grain, directing water through earthen canals, and nestling their homes against the monstrous cliffs; they forage in the forests for firewood, animal fodder, and medicinal plants; and they journey each year with their livestock to the distant pastures that lie beneath hanging glaciers high among the summits. It's all tremendously hard work, done through generations and with an eye toward the future.

What is most compelling for me about the Himalaya is not its natural beauty, as spectacular as that is, but the quiet, abiding ways in which people hold claim to the place. They have transformed a treacherous terrain into nourishing and hopeful places to live, gaining a measure of security and inspiration from them. Even as the circumstances of their lives become more tumultuous with the passage of time and a wider engagement with the world, they still find their identities within it. That is true even in places such as Kathmandu, which is forever changed, even for people like Joshi, who look to the future for their livelihood but to the past to gain a sense of who they are.

Yet none of these turning points are powerful or comprehensive enough to encompass fully the geographical scope of the Himalaya. That is what gives

it power and an enduring mystery. The sheer scale, height, and size of the mountains collapse space and disturb one's sense of reckoning. The altitudes literally take one's breath away. The distances are hard to measure in the thin mountain air. The proportions are correct—it's just that everything is so big. I suppose one may become accustomed to this over time, but that accommodation is hard to realize. It leaves you with a sense of improbability (such is the unlikelihood of the vast scale of the mountains) and also of great possibility—a dichotomy resolved finally in the magisterial presence of the Himalaya.

To gain more than a fleeting impression of all this is to walk in the mountains, leaving behind Kathmandu, and experience the Himalaya by climbing breathlessly over its high passes and descending into its spidery gorges. There's great adventure to be had in such journeys; they lead to some of the most magnificent places in the world. And while much of the effort is brutish—filled with exertion, mud and leeches, cold, bed bugs, snow, depleted oxygen, and even danger—it also leads to a sense of wonder. The Himalaya is not easily folded into one's mental map; indeed, geography is one of its most transcendent qualities.

Joshi and I left the fertile bottomlands of the valley and drove slowly up a road that led to Nagarkot, a small village situated on a ridge with remarkable views of the mountains. The lane narrowed with twists and turns that became very tight, even for the tiny taxi. Kathmandu fell out of sight below us. Thirty-five years ago, a few households straddled the ridge in a tiny farming community; a century ago, the site was occupied by a lonely fort; and now it is a bustling resort, a mish-mash of lodges, restaurants, and amusements that cater to the tourists who come to see the shining mountains.

We veered down a path between farmhouses and toward a vantage from where we could gain a glimpse of the summits that extended visibly in an easterly direction for 150 kilometers (ninety miles), all the way to Mount Everest. We stopped at a simple eating place marked with a signboard in English announcing, "Restaurant at the End of the Universe," evoking the sense of adventure many tourists must feel at the spot.

After parking the car, we climbed up a flight of steps onto a cantilevered deck that overhung a deep valley. The scene as much as exploded in front of us. The foreground was an endless succession of hills covered by farms

and pine forest, whose elevation increased steadily with distance, so that the entire landscape appeared to be tilting upward at an oblique angle. The slopes turned blue in the distance and dissolved against the cold shoulders of the high mountains. At 4,500 meters (15,000 feet) a snow line bisected the horizon, above which the peaks rose another 3,000 meters (10,000 feet) in a jagged silver arc of glistening ice and rock. The furthest distinguishable point was a peak appearing no bigger than the sharp end of a tack—Mount Everest.

I traveled with my eyes back and forth along the range, identifying mountains, lingering here and there, but Everest had a strong pull on my gaze, and I would return to it. I was fascinated by the sight of it, not so much for its physical presence—it was just a tiny speck on the receding horizon—but for its place in the geographical imagination. There is something to be said about Everest being the highest spot of land on Earth. It's a holy mountain for Himalayan people, a sort of *axis mundi* anchoring Heaven and Earth in a metaphorical embrace that spins geology on its head. Much has been written about Mount Everest, and its photograph is widely distributed, such that it has gained a worldwide celebrity status. One might never guess all that, though, by its insignificant presence on the distant horizon east of Nagarkot.

I finally looked away from Everest, into the direction from which we'd come, across the valley to the west. Of the ancient cities, only Bhaktapur was visible. It appeared much as I'd seen it from the airplane: ochre buildings amid flooded rice fields. Nowadays, the valley towns of Kathmandu, Patan, and Bhaktapur sprawl against one another, coalescing into a single conurbation, but at that time farmland still intervened between the settlements, and I was able to see them as the unique and rival places they had occupied in history. Kathmandu is the oldest and now the largest of the towns, but, during the medieval era, when the powerful Malla kings ruled the valley, Bhaktapur lorded over the others. Looking down upon it from Nagarkot, its princely history was plainly visible in the wooden palaces, brick roads, and fortress-like walls that defined the boundaries of the ancient settlement.

Beyond Bhaktapur I observed a tangle of streams, swollen from the recent monsoon rains, meandering through the countryside toward Kathmandu. Among their bends arose the great painted dome of the Bodhnath stupa, with its eyes gazing compassionately out upon a tidy cluster of red and white monasteries, each holding an ecclesiastical order of Himalayan Bud-

dhism: the Nyingma, Sakya, and Gelug sects. The chapels were filled with sculptures, colorful frescoes of saints and writhing demons, and meditating monks. Even from that distance I could discern the buildings' elaborate Buddhist architecture and rooftop ornamentation. Simpler compounds were situated nearby, shaded by banyan trees, providing houses for the clergy.

The valley formed a huge natural bowl that once contained a lake. The water emptied when seismic shifts, and erosion rearranged the geometry of the mountains—that, at least, is the geological explanation for it. Legend has the Buddhist saint Manjushree investigating a blue flame arising from a lotus blossom in the middle of a lake. To reach the spot he cut a huge swath out of the hills to the south with his sword, allowing the lake to drain and exposing the valley. The cut became the Chobar Gorge. The great stupa at Swayambu was constructed on the hill where the alleged fire had emanated from the spectral flower in the lake. Subsequently, the valley was settled by the Newar tribe, whose artistry still graces its fine old buildings, and eventually it became the capital of the Himalayan kingdom of Nepal.

When we turned our attention again northward, Joshi pointed out a spot in a cleft in the mountains that held his village. It was visible now as a tight knot of homes clinging precariously to a distant ridge. The immense scale of the scene miniaturized everything—the hills and valleys, forests and rivers, Joshi's village and Mount Everest. The Lilliputian effect lent an old-world charm to the landscape that washed across the grit of everyday life, leaving it to the imagination and future explorations.

With its commanding vantage over the central Himalaya and proximity to Kathmandu, Nagarkot was destined to become a tourist resort. Mountain watchers ascend daily to spend a night there in order to gain a sunrise view of the summits. The clear atmosphere is a balm to city life. Beyond that, however, the place has little to offer, and for most people, including the couples who surreptitiously frequent its love hotels, Nagarkot is a one-night affair. We spent even less time than that, only an hour or so to eat a meal and enjoy the view, before heading back down the valley. I liked it best years ago, when Nagarkot was still a tiny straggle of farms, but the village, despite its development, has retained an appeal for the extraordinary sight it affords at the end of the road. For that reason I still frequent the place whenever I find myself in Kathmandu.

Looking north beyond the lodges and restaurants of Nagarkot, the high mountain scenery has changed very little over the years. The valley, on the other hand, tells a much different story.

In 1950, Kathmandu had a modest population of 55,000 residents. Twenty years later, it had increased fourfold to a quarter million. Now, almost a million people live in the metropolitan area. The exploding numbers result mainly from people moving into the city from the rural areas, fleeing a harsh life on impoverished farms in the mountains or civil unrest. The swell of humanity fairly bursts the city's seams, putting an enormous strain on its slim infrastructure and the scant public services and extending the metropolitan boundary onto the outlying valley. The roads have seen little improvement in the past thirty years. Rusting sewer lines bleed into the water pipes and contaminate the drinking supplies. Power outages roll across the city in regular waves of darkness. The wealthy retreat into gated compounds under guard, protected from would-be intruders by barbed wire and shards of broken glass atop the perimeter walls. Meanwhile, more people live each year on the streets, begging for a life.

A tension has developed in Kathmandu in tandem with its transformation from a medieval town into a developing metropolis. A friend who lives there remarked that he likens the effect to what one might experience on the verge of a significant moment, as if the city and he were caught in a single breath, hesitant to exhale for fear of further extinguishing the past. Thirty years ago, social and economic events slowly unfolded to suggest the changes that now engulf Kathmandu. People then were impatient for something new. When I discussed this with Joshi in Nagarkot some thirty years ago, he said that he looked forward to the city's growth, imagining then that it would enlarge his own life. Now, decades on, I wonder what he must think, as an older man whose memories contain both the old and new place.

The turn of the twenty-first century saw Kathmandu besieged in ways that threatened not only its past, but the very future of the country. A violent insurgency, led by Maoist ideologues and borne in the poverty of the remote western hills, had spread across the kingdom. The rebels surrounded the valley in revolutionary strongholds and tightened their grip on the city by blockading the roads leading into the valley. They made preparations to bring their

rural-based revolution to a new urban battlefield, even onto the doorsteps of the Royal Palace. The insurgents sought nothing less than the demise of the monarchy and the imposition of a Marxist republic.

Inside the valley, people anxiously awaited, stripped of representative government, their leaders put in jail by a despotic king caught in a pincer between the revolutionaries and the Royal Army. When asked, the taxi drivers in Kathmandu were likely to say, "*Nepal khatam ho*" (Nepal is finished).

In the spring of 2006, massive civilian demonstrations shook the streets of Kathmandu, promising to change the tide of history in Nepal forever. It began with students burning tires and furtively scrawling political graffiti on the sides of buildings, fleeing in packs from the police, who came upon them and furiously waved batons and shot rubber bullets at them. Soon, though, the students were joined by others—teachers, doctors, lawyers, common laborers, journalists, university professors, businessmen, housewives, and finally government clerks and officials. Within days a vast cross-section of Nepalese society walked away from their work and poured into the streets, joining the throngs of students already there, all marching and carrying signs and shouting for democracy and the demise of the monarchy and proclaiming peace. It was an unprecedented display of frustration and hope.

The demonstrators persisted until the king relented, the army withdrew, and even the revolutionaries backed down. In the end, the citizens in the streets were victorious. They peacefully accomplished in a matter of days what a decade of violent insurgency, government ineptitude, and international diplomacy had utterly failed to achieve: they brought an end to the rule of a corrupted king and his henchmen and took back their city and country. It was time for atonement.

I'm in Kathmandu for a few days en route to Tibet and find that the past few years have not treated the city well at all. The king is gone, but the hope of a new democracy has turned to despondency over the lack of any progressive politics. The elected political parties (of which there are more than a dozen) seem unable to unite around a coherent set of national goals. City dwellers see a steady rise in the price of basic goods and a drop in the level of government services. The roads are almost beyond repair. Power outages rotate through the neighborhoods with precision clockwork, disrupting the affairs of ordinary life—people say they are

the only things they can count on with any degree of regularity. Trash piles up in the streets because municipal workers, logically enough, refuse to work without pay. Even the national hospital closes on a whim, whenever the government doctors decide the wretched sanitation conditions or abysmally low salaries are insufferable. Meanwhile, violent strikes paralyze the entire city whenever the agitating political parties make impossible demands.

Nepal may eventually break apart as a new "federalism," organized along ethno-territorial divisions, threatening to fracture the country into numerous autonomous parts. Kathmandu, as the nation's capital and its largest city, bears the burden of these trends. The one-time guerilla leaders of the Maoist insurgency are now counted among the nation's elected leaders. They live in plush city homes, drive SUVs, and sit amid garlands of marigolds in front of television cameras, speaking of national unity while maintaining their private militias. Discourses about "divide-and-conquer" tactics fill the pages of the daily papers. The politics are palpable in the city streets.

To escape the chatter I duck into a tiny barbershop and take a seat in a high-back, frayed vinyl chair. The barber, an old-time acquaintance of mine, nods and then disappears for a moment behind a heavy curtain, reappearing with a cup of steaming tea for me. I hear his wife moving softly behind the drapery, hidden away in the dark room where they sleep at night. The barber lights a stick of incense and hits the play button on a cassette of Sufi music. A searing melody of love and sorrow mingles with the sandlewood smoke. A few local boys drift into the shop to borrow a comb and preen in front of a mirror. The walls are pasted with old Hindu calendars and colorful pictures of a dread-lock Shiva sitting atop Mount Kailas. With practiced movements, the barber wipes the counter and gathers together his implements—brush and soap, a kettle of hot water, razor blades, a fresh towel, shaving cream, and alum styptic bar—treating them carefully, as if they are small treasures. I sink into the chair, and the city slowly disappears while the barber begins the rituals of my morning shave.

I know that it is into such intimate settings, diverse and multitudinous across the city, that Kathmandu's residents escape the weariness of a frayed urban society. The tiny plazas and courtyards that lie hidden behind the high brick walls, the temple enclosures and tea shops and barbershops, and the myriad other small-family businesses that line the streets—these are

the places where quiet still resides and gentleness prevails amid the clamor of the city, where people speak to one another in the hushed and respectful tones that the Nepalese kindly refer to as "sweet words," their conversations a kind of mantra that reaches in one another's soul. These are the cherished eddies of old Kathmandu: places of equanimity.

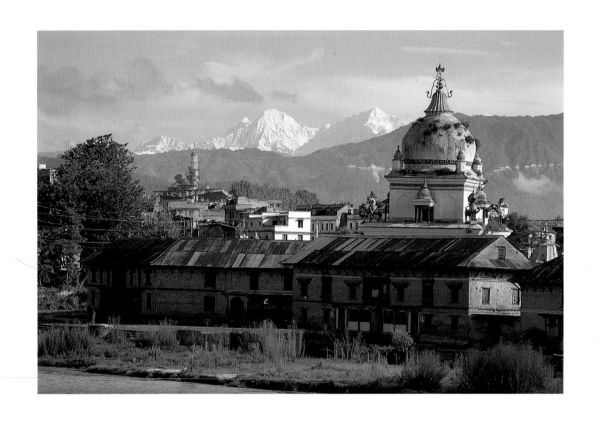

1 *Kathmandu's city center, with clear views north to Langtang Himal, Nepal, 1985.*

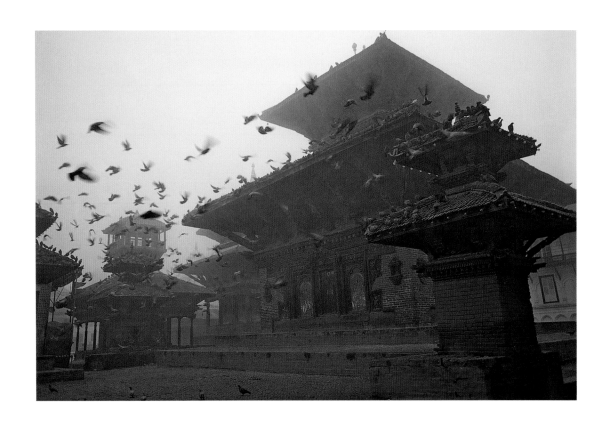

2 *Winter morning at the pagoda-style Jagannath Temple in Kathmandu, Nepal, 1987.*

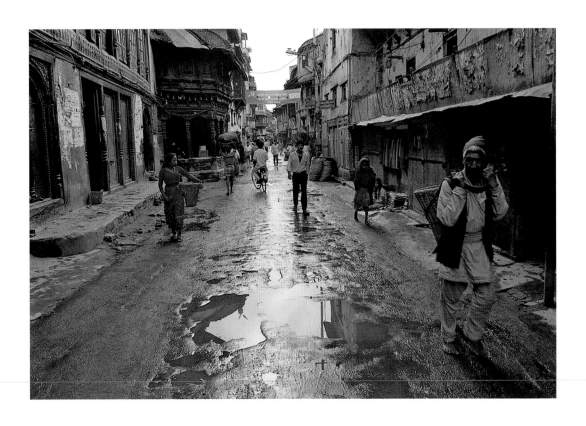

3 A back street in Kathmandu, Nepal, during the summer monsoon season, 1990.

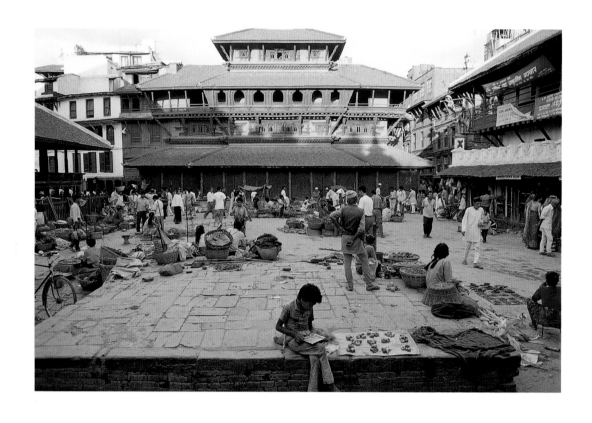

4 *A neighborhood market in the old Ganabahal sector of Kathmandu, Nepal, 1990.*

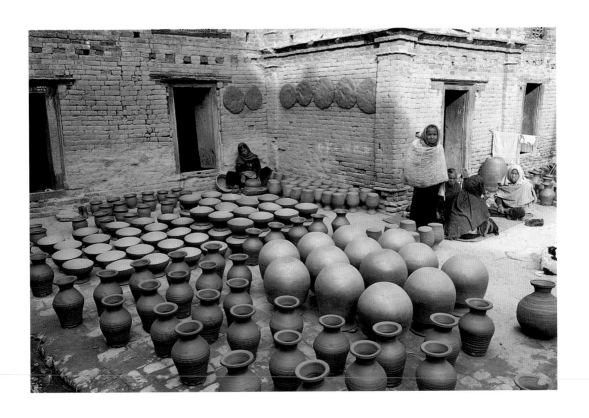

5　*A potter works in the village of Thimi in the Kathmandu Valley, Nepal, 1987.*

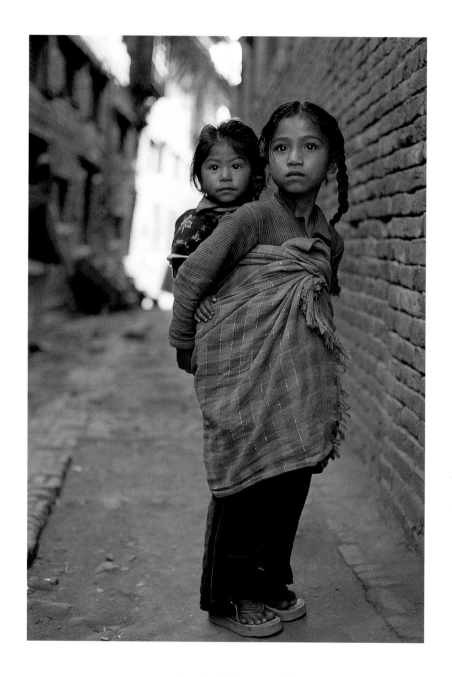

6 Street sisters in Bhaktapur, Nepal, 1985.

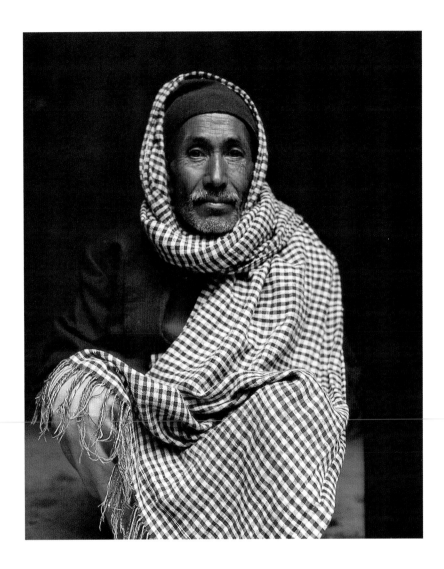

7 *A Newari shopkeeper in Kathmandu, Nepal, 1985.*

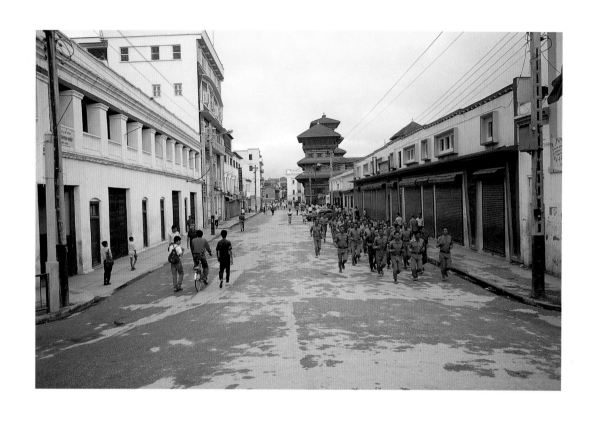

8 *The police maintain a strong presence in the streets of Kathmandu, Nepal,*
in the midst of strikes and civil unrest, 1990.

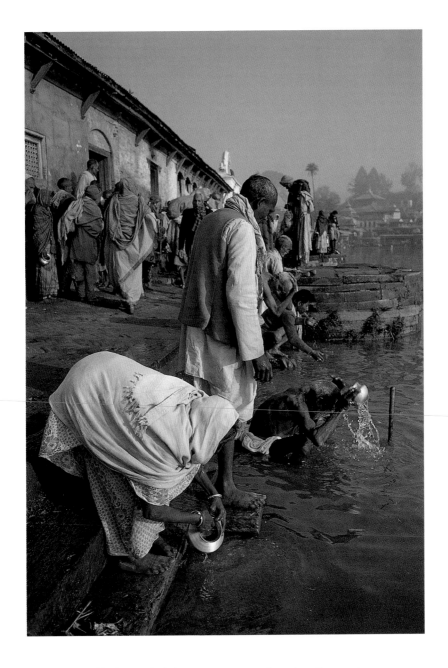

9 *Ritual bathing in the holy Bagmati River, Kathmandu Valley, Nepal, 1985.*

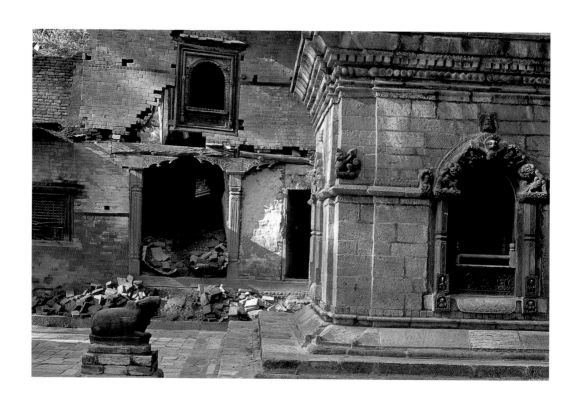

10 *Ruins of Pashupatinath Temple in the Kathmandu Valley, Nepal, 2004.*

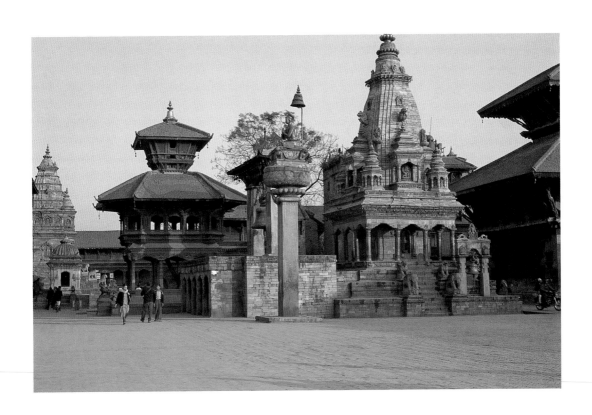

11 *The central square (dubar) of Bhaktapur in the Kathmandu Valley, Nepal, hosts*
exquisite architectures and is recognized by the United Nations as a World Heritage Site, 2007.

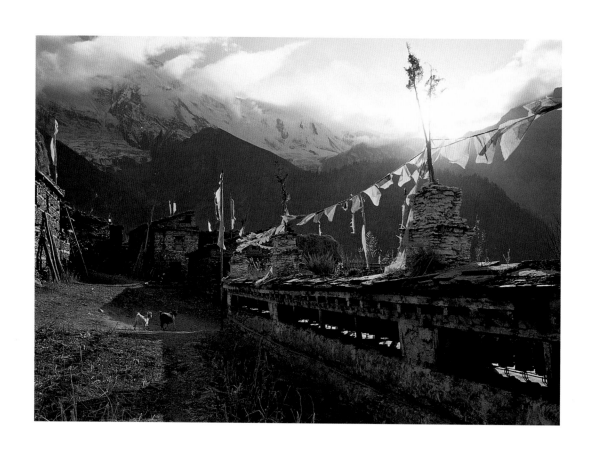

12 *Prayer flags mark a pilgrims' trail through a high-altitude Buddhist village in Nepal, 2007.*

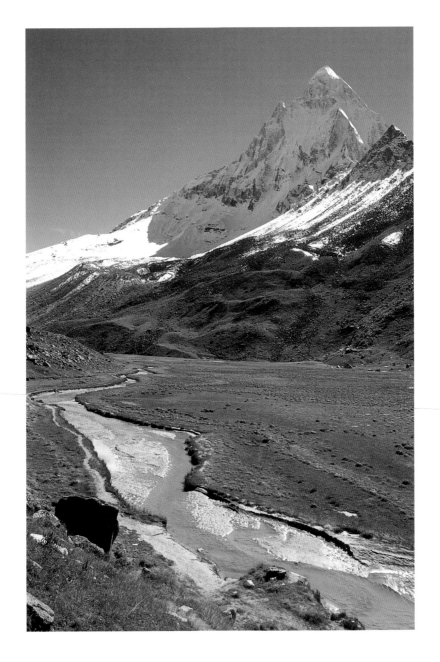

13 *Yak pastures and a sacred mountain in the high Himalaya zone of India, 2007.*

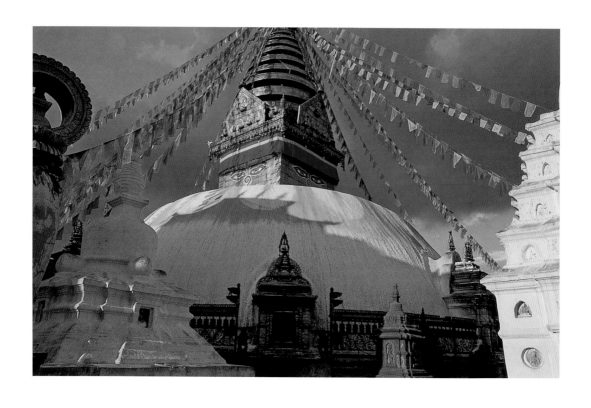

14 *The magnificent stupa of the Swayambunath Temple is a famous
landmark in the Kathmandu Valley, Nepal, 2007.*

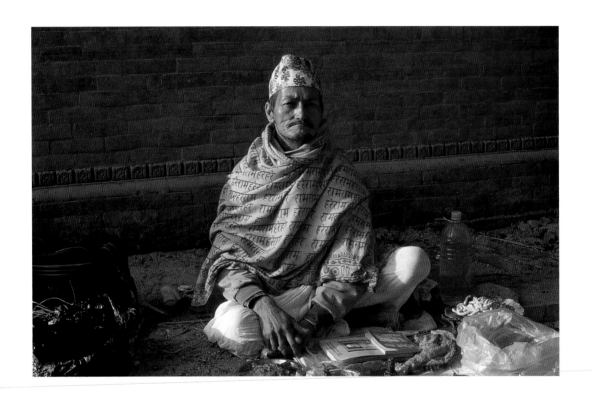

15 *A village priest provides spiritual counsel at a temple entrance in Budhanilkantha, Kathmandu Valley, Nepal, 2007.*

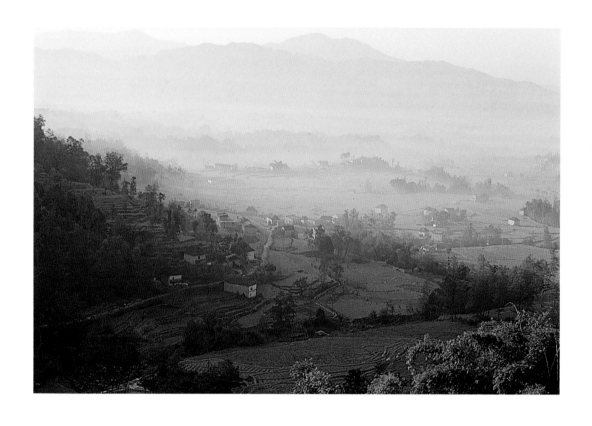

16 The view from Nagarkot Road across the Kathmandu Valley, Nepal, 1994.

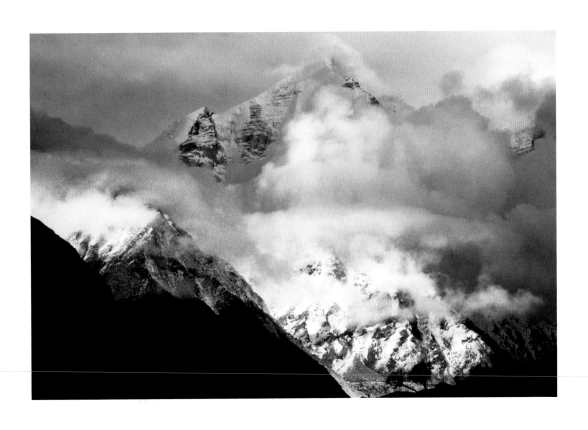

17 *Bhagirathi Peak II (6,521 meters; 21,395 feet), India, 2004.*

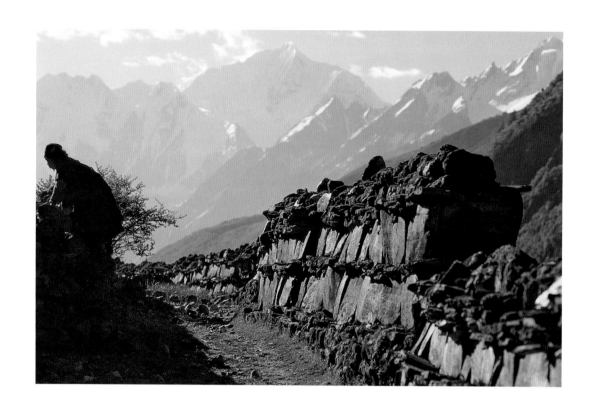

18 *Rows of inscribed tablets, called* mani *walls, adorn the trails*
in the Buddhist high country of Nepal, 1988.

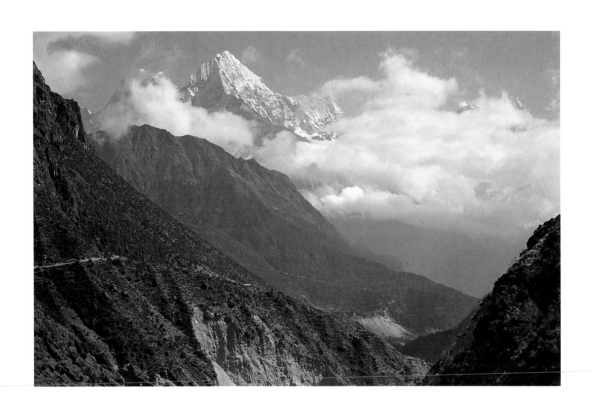

19 *Walking trails link villages in the high Himalaya zone of Nepal, 2007.*

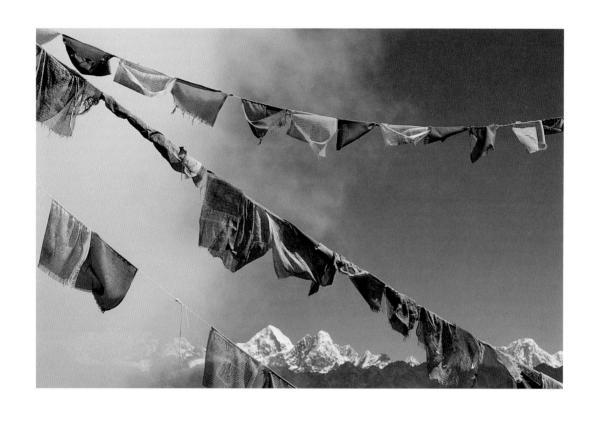

20 Prayer flags atop a mountain pass in Nepal, 2002.

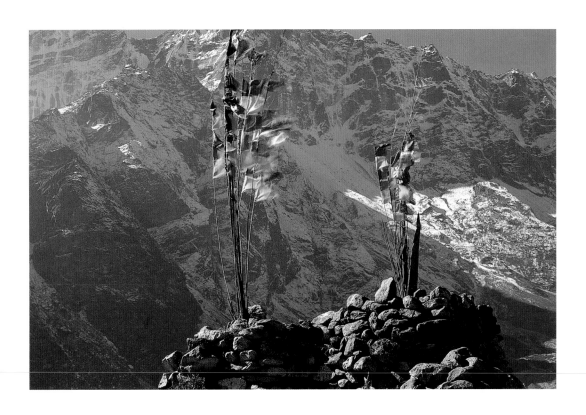

21　*Prayer flags atop a ceremonial cairn in Nepal, 2007.*

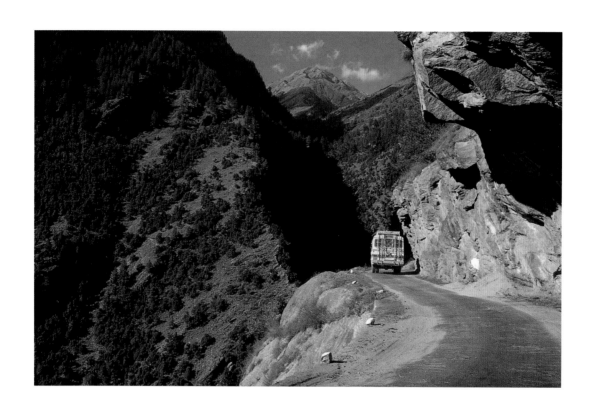

22 *A mountain road cuts into the cliff above the Baspa Valley, India, 1996.*

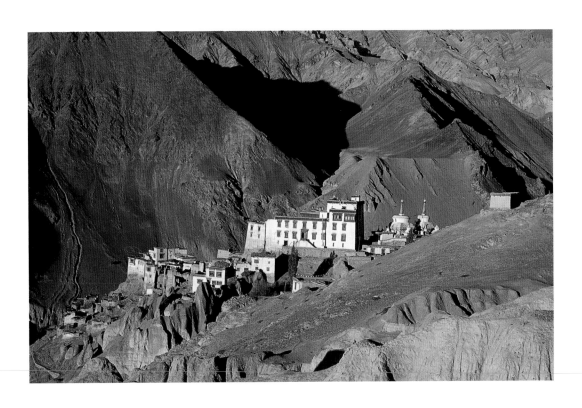

23 *The monastic settlement of Lamayuru is a gateway settlement to Zanzkar, India, 2004.*

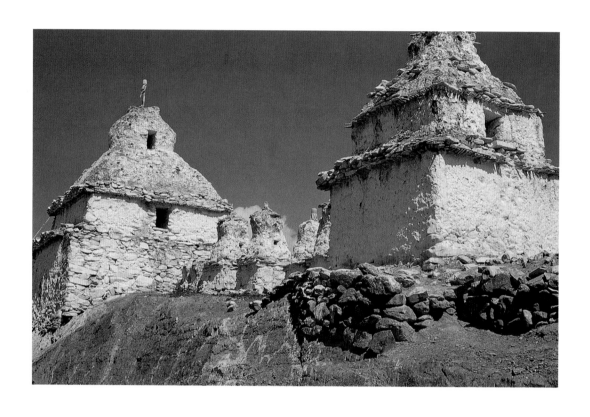

24 *Religious monuments (called* chortens) *at Alchi, India, 2004.*

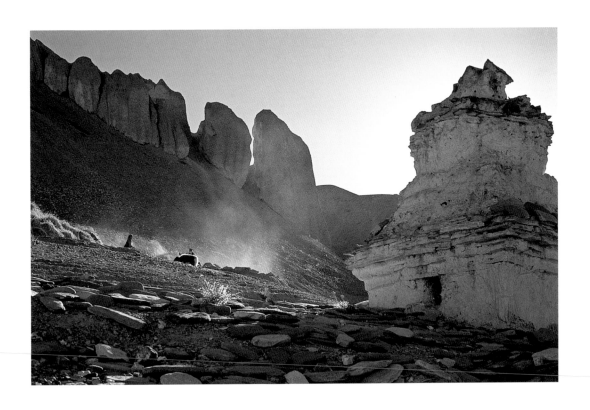

25 *Farming the bleak, rocky terrain of Zanzkar, India, is a difficult proposition, 2004.*

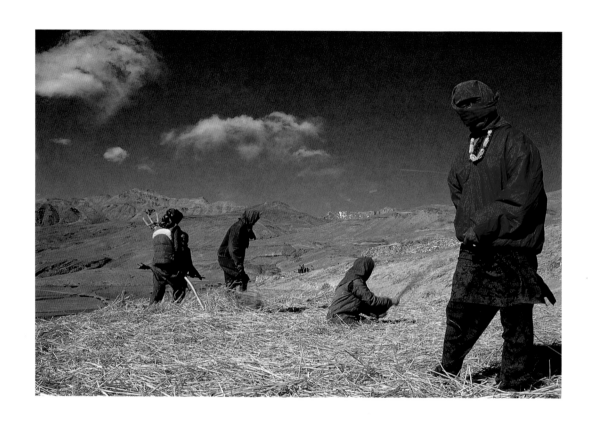

26 *Harvesting barley in Kibber (4,116 meters; 13,504 feet), Spiti Valley, India,*
one of the highest permanent settlements in the world, 1994.

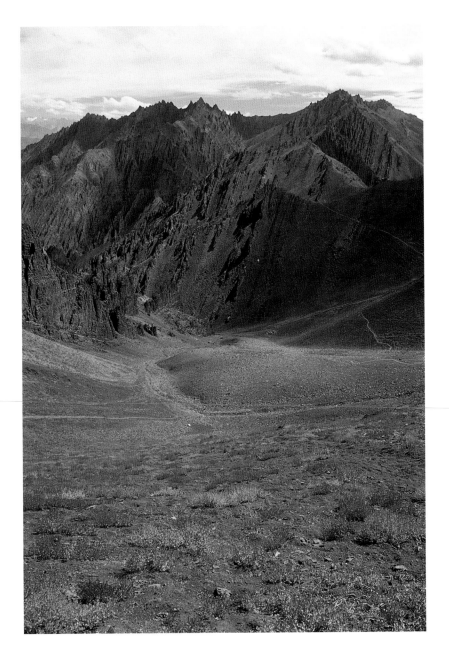

27 *Exposed strata in Zanzkar, India, 2004.*

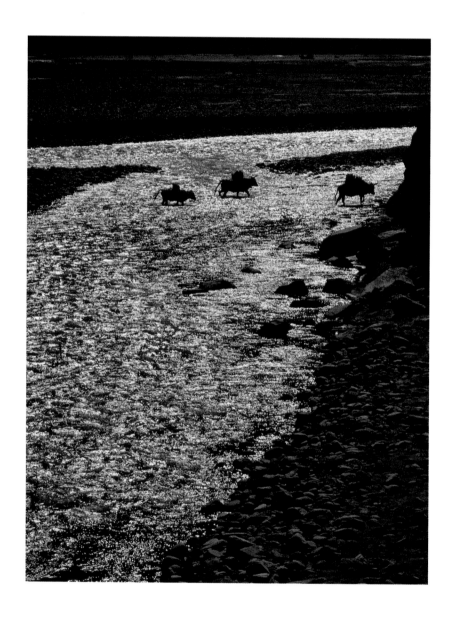

28 *A yak crossing in the trans-Himalaya region adjacent*
to the Tibet Plateau, India, 1987.

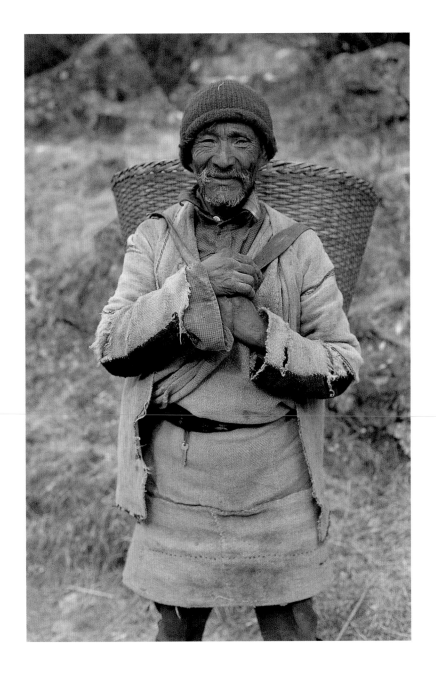

29　*Villagers in Nepal use burden baskets to gather fodder for livestock, 1985.*

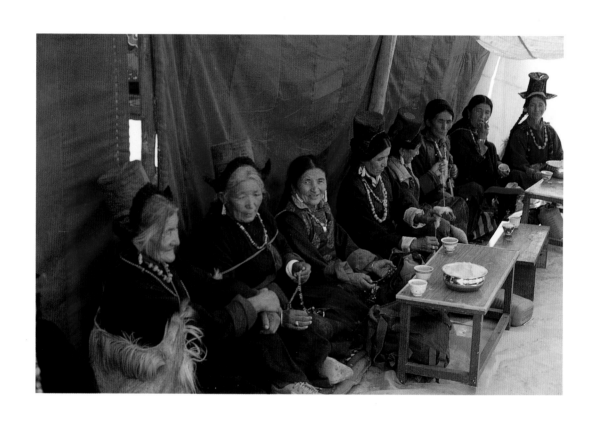

30 Villagers gather for a meal during a wedding ceremony in Ladakh, India, 2005.

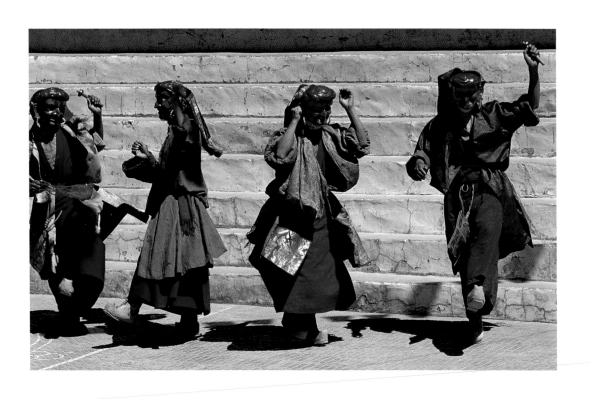

31 *Monks in a Buddhist monastery perform a Cham ceremony,*
a religous dance, in Ladakh, India, 2004.

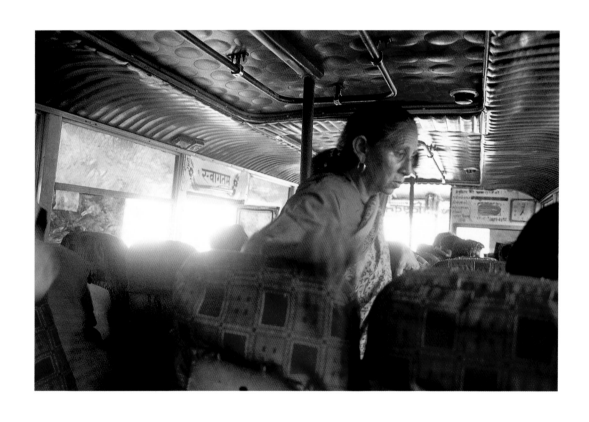

32 A village woman on a local bus heading to the Baspa Valley, India, 2004.

TETHYS RISING

(Baspa Valley and Zanzkar, India: 1995 and 2004)

I WAS WALKING ON A NARROW RIDGE above the Baspa Valley in the western Himalaya. Snow and ice crystals glittered around me in the cold sunlight, and the frigid air resonated as if its frozen molecules were about to crack. The hoary silence was disturbed only by the crunch of my boots on the frozen ground. Below me, nestled into the rocky moraine of a glacier, lay the field station of a glaciologist from India's famous Wadia Institute of Geology. I'd met the man several days earlier in Chitkul, a tiny village tucked into a fold of the Kinnaur Kailash Range, where he was arranging delivery of supplies to his research station located high in the mountains. The logistics were complicated—ponies would be needed to carry the loads up to the snow line, and, after that, it was the burden of porters. I'd introduced myself to the man and asked if I could join him at his field camp in order to see something of the high country. He agreed, suggesting I might be able to assist him with some of his work. The man's colleague had a stomach virus and was advised to remain in the village for a few more days.

The following morning I gathered my gear from the lodge where I'd been staying and joined the man for the return trek to his glacier encampment. Our climb passed, first, through a cedar and pine forest and, then, across sloping green pastureland dotted with sheep. We came across shepherd's huts and accepted numerous invitations to stop for tea. At dusk, we pitched our tents near a stream at the base of a large snowfield, where a break in the slope of the mountain provided a bench for our camp and pack horses. We'd followed no distinct trail, but the geologist frequently passed this way,

and the local shepherds were familiar with the terrain, so we climbed a fairly straight line toward a high ridge, beyond which was the man's research station.

When we topped the ridge the following day, the mountains splayed out generously before us. On one side, craggy peaks lined up one after another like marching sentinels, overlooking dark green valleys. In another direction, the voids gave way to a distant plateau, whose desolation and purple colors told of the desert landscapes of Spiti and Zanzkar. The monsoon rains of summer barely penetrated those provinces, and their barren terrain showed the stark, bedrock underbelly of the mountains.

A few hours along the ridge put us into the heart of the snowfields, and a short while later we arrived exhausted at the field camp. I set up my tent, stowed my gear, and then sat down to rest and marvel at the place. The geologist soon busied himself with unloading equipment and supplies and suggested that I explore a nearby promontory, saying it would provide a good view of our surroundings.

It was a short but taxing climb through the thin air and, although not technically difficult, a tricky ascent to get to the top of the summit. The afternoon sun had softened the snow, making it difficult to walk, and soon I found myself out-of-breath, post-holing along a narrow ridge, with the land falling steeply below me on both sides. Standing atop the promontory and facing south toward the Indian Ocean, I was straddling Asia. The watersheds of the Indus and Ganges rivers met there along a great topographical divide. On my right, the melting waters plunged over rocky ledges and through pasture, gathering in the tangle of tributaries that feed the Sutlej River before it joins the Indus River on its southward flow to the Arabian Sea, some 1,500 kilometers (1,000 miles) away. The streams on my left descended to the Bhagirathi River to form the headwaters of the Ganges, which, in turn, collects all the rivers of the central Himalaya on its way across India to the Bay of Bengal.

The tributaries carved deep gorges that fell toward even larger valleys set beneath the snowy summits and plateaus. Below me, tucked neatly into the lee of the moraine, the geologist's bright-yellow tents flapped in the wind. The porters who had brought up the supplies from Chitkul were already descending the mountain and appeared in the snow as a line of ant-like specks marching across its glittering white surface. I returned to camp when the sun slid behind a mountain, and it became immediately cold.

The geologist's name was Narendra. During our climb to the camp, I found that, in addition to his glacier studies, he's a mountain climber, pilot, ice cave diver, and former army man who had spent eight dangerous months atop the 5,800-meter (19,000-foot) Siachen Glacier defending the India-Pakistan border. He was a music lover, and wires from a portable cassette player dangled from his ears much of the time we trekked. His favorite songs were the 1960s-era Bollywood film tunes. The man had a thick black beard, piercing eyes, and wore a stout, woolen cap knitted by the local shepherds. He walked with a strong, rhythmic gait that suggested a lifetime spent in the mountains. His face was darkened from the sun, and his white teeth flashed when he smiled.

Narendra was deeply concerned about what is happening to the alpine glaciers above the Baspa Valley. The glaciers are melting faster than the seasonal snow replenishes them, and, as a result, the ice accumulation zone moves higher in altitude each year. In effect, they are shrinking. Measurements taken by him and a colleague on the 5,400-meter (18,000-foot) Gor Garang Glacier, located directly across the valley from us, suggest that one-fifth of a square kilometer of ice was lost to warming temperatures in just the preceding two years. At that rate, he explained, the glacier will be gone in less than half a century. Similar losses are noted for ice sheets elsewhere in the Himalaya, with ominous implications.

At first the melting ice will increase runoff into the valleys, posing a threat of floods to low-lying areas but in the long term leading to water shortages during the critical summer growing season. For ages, the Himalayan glaciers have served as freshwater reservoirs, sending meltwater in the warm months to the farms located further down in the valleys. Now, as air temperatures worldwide increase and the glaciers melt away, the supply of summertime water in the most vulnerable regions of the Himalaya is threatened.

It's a disturbing problem for villagers in places such as Chitkul, who have neither a role to play in the cause of the climate change nor any power to stop it, yet they find their very lives threatened by it. It's also a matter of concern for scientists like Narendra, who was working atop the Baspa glaciers in order to comprehend better the local dimensions of the Himalaya-wide dilemma.

I spent several days with the geologist, shadowing him on his daily circuit and helping out as I could. It was hardly routine. To take measurements

and map the ice field we had to scramble along precipices that often were slick with water from the melting ice. We used crampons and ice axes in places, but even those did not always secure our footing. It was slow going. The ultraviolet light and dry air burned and cracked my exposed skin.

The nights were chilling, and I developed a racking cough from the cold, thin air, which made sleep difficult. I hadn't acclimatized to the altitude and paid the price for it in discomfort. It could have been much worse, though. Under serious conditions, a person suffering high-altitude sickness may experience intense headaches: in the most extreme cases, dilation and rupturing of blood vessels can occur in the brain, or there is the suffocating accumulation of fluid in the lungs. In my case, it only led to fitful sleep the first few nights in the high camp.

Narendra had set up small weather and seismic recording stations on the ice, so during the day we were all over the glacier, checking data and fixing little problems with the devices. In the afternoons, when the work was complete, we'd return to the camp near the snout of the glacier, in a spot protected from the wind, and I would relax while the geologist recorded his notes or tinkered with equipment. From the camp I could see far into the distance. It was fine to be so high in the mountains, amid the icy peaks that seemed to go on forever, and to look down upon verdant pastures and forests, tumbling white-water rivers filled with trout, and farms in the distant valley.

The man's colleague arrived in camp one day looking fit and in good spirits, ready to continue his work. The two scientists made plans to traverse the ridgeline and set up new monitoring stations on a nearby glacier. They asked if I wanted to come along. I declined, choosing to linger at the camp for another day, climbing a bit and exploring nearby promontories that offered good views of the Kinnaur Kailas Range and the summits of far-away Zanzkar. The following morning I descended the mountain to Chitkul and continued my journey north toward Spiti and Zanzkar.

Glaciers such as those studied by Narendra above the Baspa Valley play vital roles in the hydrology of the Himalaya, and they are in retreat everywhere in the mountains. By some estimates, a third of the mountain ice mass has disappeared in the past fifty years, and at current rates of temperature increase the ice will disappear even faster in the near future. Not only has the surface

area of the glaciers diminished, but also their depth and overall volume. The immense ice towers will not function well in the future to regulate freshwater supplies; if they lose much more of their size, the life they support is threatened. It's a looming problem not only for people living in the mountains, but for anyone residing alongside the great rivers of Asia. That's because the Indus, Ganges, Brahmaputra, and Irrawaddy rivers in southern Asia, as well as the Yangtze River in China, all owe their origins to the Himalayan glaciers. More than a billion people will be impacted by their demise: irrigation and drinking water will become less dependable or disappear altogether, estuarine habitats will diminish, fish populations will decline, and the navigability of the rivers will suffer.

In some mountain localities, the high melting rate has already overfilled lakes that form at the terminus of the glaciers, straining their natural earthen dams, sometimes causing them to burst. In this case, the impounded water escapes in flash floods that rampage down the valleys. It happens quickly, often precipitated by a minor seismic disturbance or when an especially large chunk of ice calves off from the glacier and plunges into a lake, usually without much warning. Such events, called glacial lake outburst floods (known as *glofs*), pose serious hazards to alpine landscapes and communities and may result in catastrophic losses to human life and property.

The disappearance of the glaciers poses additional dilemmas to the Himalaya that may not be so readily observed to humankind because it unfolds over Earth's history. In the geological past, the glaciers have sculpted the summits into their spectacular forms, and their absence in the future will render a very different kind of alpine landscape. Glaciers are slow-moving rivers of ice. Gravity pulls them downslope, where they act as giant rasps to grade the terrain into deep, U-shaped valleys, linear moraines, and sharp cliffs called *arêtes*. In places where a glacier has stayed put for a long time, deep basins are carved and then fill with water when the ice melts, forming the lovely alpine lakes called tarns. Most spectacular of all, the chiseled peaks themselves are created by the glaciers: rock faces and steep cornices in an infinite variety of sizes and shapes—pyramids, domes, needles, triangles, and blunt-nosed massifs—that sparkle gem-like in the high altitude sun, cut and beveled and buffed by the glaciers out of the crystalline core of the Himalaya. The future shape of the Himalaya is truly at risk.

Scientists offer detailed explanations for the upheavals that produce the rocky palettes eroded by the glaciers. The mountains take shape from tectonic uplift, in which the Indian subcontinent drifts in a northerly direction, compressing the primordial Tethys Sea that once intervened between India and Tibet, and slips beneath the Tibetan Plateau. This collision has raised huge chunks of the lithosphere into the sky so that gigantic silvery and black sheets of granite, gneiss, and schist form rock walls and summits that tower eight kilometers (five miles) high. These features define the Himalaya's central upthrust zone, upon which the glaciers sit in icy triumph. North of this zone, layers of softer materials deposited more than 60,000,000 years ago by the waters of the ancient Tethys Sea cling like sedimentary skin to the crumpled earth and shape the plateaus and undulating panorama of places such as Zanzkar and Ladakh. The raised Tethys seabed extends far north of the Himalaya into Tibet and the high steppe country of interior Asia. South of the main uplift zone, the mountains descend spectacularly in ridges and eroded valleys toward a skirt-like piedmont plain, which, in turn, falls away to the Ganges plain of northern India.

The word *himalaya* is of Sanskrit origin and in its vernacular usage means "abode of snow." The local people consider the range to be the throne of mighty gods. In its tectonic energy they see all the power of the preternatural world, where the seismic rumbles of the geological movements and the howl of the mountain winds are the gesticulations and sighs of gods. For many Hindus, Shiva still rules the world from his natal perch atop the summit of Mt. Kailas, and his breath—moist and warm in the summer, cold in the winter—is believed to bring life to the mountains. Buddhists, meanwhile, find a pantheon of saint-like bodhisattvas strung across the range. In both cases, the supernatural forces must be propitiated in order to reduce the risks for humans of living in such a volatile world. Life in these places is a matter of faith.

Geologists, meanwhile, refer to the mountains as "high energy environments" and attribute the dangerous conditions in the Himalaya to the unrelenting and counterpoised forces of gravity and tectonic uplift. In the scientific view, there is little to be done about it: landslides and rockfalls are common, especially during the monsoon months when the slopes are saturated with water, and they will occur despite the intervention of man or gods. Earthquakes, too, occur frequently and may violently shake the mountains

with horrendous consequences. The deadly tremor that struck northern Pakistan in the autumn of 2005, leaving 80,000 people dead, registered a 7.6 magnitude on the Richter scale—one of the largest on record—and the prospects for other dangerous seismic events are high all across the range. (By comparison, the Haiti earthquake of 2010 registered 7.0; the San Francisco earthquake of 1906 was 7.7–8.0; the Chile earthquake of 2010 was 8.8; the Alaska earthquake of 1964 was 9.2; and the Chile earthquake of 1960—the largest ever recorded—was 9.5.)

These geological occurrences are tied to the physical life of the planet, and they are to be expected—the Himalaya, after all, continues to rise from its origins in the Tethys Sea. When the seismic disruptions occur without warning, though, they often are seen by native people as the rash, sudden, and inexplicable acts of a god. Such is the power not of mountains or deities but of the human imagination and a deeply rooted belief in the way the world works. When the forces of geology are attributed to the acts of gods, a commensurate fatalistic attitude may emerge about life and events on Earth. We are held to be powerless against them. In such thinking, the threat of tectonic catastrophes pales against the daily challenge of survival, with which everyone who lives in the mountains must contend. Life in the Himalaya may be fraught with danger and uncertainty, but it also is enduring.

I found relief from the biting wind in the lee of an outcrop atop a 4,875-meter (16,000-foot) pass at the end of a month-long traverse of Ladakh to Zanzkar. From this vantage I could see much of Zanzkar: the steep descent to the Markha Valley, from which I'd come, and, farther still, past the Spiti province toward the Kinnaur Kailash Range, which overlooks the Baspa Valley, and then northward to the great Indus River valley and the Ladakh Range, beyond which lies the harsh, uninhabited Aksai Chin desert. Ravens screeched and soared overhead, carried by updrafts that spiral into the sky. Prayer flags, tethered to slender poles and shredded and torn by the wind, fluttered above me for good luck as if in whimsical goodbye to the arduous journey. They are placed at the pass by traders and pilgrims as gestures of respect for the mountains, and each new caravan adds to the tangled strings of frayed cloth so that the tapestry resembles an immense, vibrating knot of tantric design. Tall stone cairns mark the pass for those who may get caught crossing it in deep snow.

The tectonic history of the Himalaya is visible here in amazing clarity. That land is void of vegetation and the sky of atmospheric haze. The terrain is illuminated by sunlight so intense it seems to burn through the very crust of Earth itself. With almost x-ray penetration, it exposes the geological structures, silhouetting the linear features of the Indus Valley, where the river winds through sedimentary and volcanic rocks. This is the seismic axis that separates the Tibetan world from the high peaks of the main Himalaya. South of the pass are the monochromatic hues of Zanzkar—signifying the Tethys sediments that overlay the buckled and folded terrain. North of the pass are the snowy ranges of Ladakh.

The line of sight also takes in the crystalline structures forming the highest Himalaya. The peaks are composed of granite, gneisses, and quartz, some embedded with precious gemstones that originate in the heat and pressure of geological upheaval. Even seashells are found on the icy summits—additional reminders of the fact that the Himalaya arose from the marine environment of the Tethys Sea.

The striations of color in the rock around me glowed in the failing light, and the deepening shadows accentuated the geological fissures in the vertical walls. The landscape proved a mesmerizing sight, both for its raw beauty and the seismic power underlying its formation. I felt I was standing on the edge of an abyss, overlooking the very marrow of the planet, above a rocky terrain that shimmered in the low angle of the sun, such that I could almost see the mountains take shape before me.

It was near the end of the day and time to descend to a lower elevation. I hadn't anticipated still being that high on the mountain. Earlier in the afternoon, a caravan crossing the pass had gotten tangled up on the ropes that held the prayer flags above the trail. The lead horse, spooked by the snapping sounds and fluttering fabric, galloped away, dragging a hundred feet (thirty meters) of colorful flags in its wake. The other ponies followed in quick pursuit. The stays loosened on their loads, causing them to slip and spill onto the ground, further alarming the ponies as they frantically set off in new directions.

I was nearby and about ready to leave the pass when it happened. The horseman—just a boy—asked me to stay behind and help him retrieve the gear that now lay strewn about across the slopes. We scrambled hard to locate the packs, traversing steep inclines, hauling duffel bags, tents, food, cooking

stoves, and other camp equipment up the rocky cliffs. Eventually, we got most of it. The lead horse, though, was out of reach. It had taken a steep route down a side valley and disappeared in the distance.

When we finished the job as best we could, calmed and re-packed the frightened animals, I set off. I was on the final leg of my journey and sought relief in a valley where I knew a village was located. It was already too late to make it to the settlement that night, but I wanted at least to reach a lower altitude and find water and a sheltered spot to camp. After gathering my things and saying goodbye to the boy, I literally bounded down the trail in Himalayan style, almost running, using the force of gravity to speed me along, carefully watching where I put my feet. In an hour, I arrived at a small side canyon with a stream and a sandy bank protected by boulders—a perfect place to camp.

Zanzkar is desolate, stark and luminous, and brilliantly clear, filled with pastel hues and a blazing day-time light. The night skies are star-filled. It's dry as a bone, and the air is thin: imagine the U.S. state of Nevada hoisted 4,575 meters (15,000 feet) into the sky. The high altitude, desiccating sun, and steep, rocky trails make walking a chore. It's brutally cold at night, and during the day the sun and wind sear the land. After a month's exposure to the climate, my face and hands felt like ancient peeling parchment. The discomforting exposure of Zanzkar, though, is what makes it such a good place to observe the bedrock bottom of the Himalaya—the surface is laid bare here and its skeletal girding wide open to view.

This zone is known as the trans-Himalaya, a region of high plateaus and snow summits beyond the crest of mountains. In places, it's gouged by deep river gorges and contains tiny, isolated fertile valleys of green plants and rushing streams. In the highest spots, where temperatures remain freezing, the mountains stand as icy white pinnacles against an azure sky. Most of the terrain is inhospitable, without good soil or water or much in the way of vegetation, and largely devoid of humanity. In a few isolated places, however, the trails pass through tiny villages overlooked by imposing monasteries, where humankind has settled precariously into the tectonic lap of the mountains.

The ancient temple aeries are seen first, emerging from the landscape as if sculpted from Earth itself. There are quite a few of them in Zanzkar—at

Stongde, Zangla, Phugtal, Lamayuru, and other places. They mostly are made of mud and rock and painted in ochre and other colors that match the earthen tones of the surrounding land. The slab-like shapes of the monasteries evoke a lithospheric effect, as if they are cut from the planetary crust. It's not difficult to imagine them having been there all along, through the geological epochs, rising up with the mountains out of the Tethys Sea, riding the seismic uplift like a gigantic, cresting wave, surfing to the altitudes where they now perch in splendid solitude.

Beneath the monasteries the white-washed village houses of adobe and hand-hewn timber tumble down the mountainside atop one another in an architectural free fall. The cloistered homes are interspersed by a warren of narrow footpaths, connected by adjoining roofs and lit by tiny, square windows. The toppled cubist effect renders an Escher-like quality to the settlements. Their worn patinas show great age, and the eroded mud gives the illusion of places on the verge of melting into the mountain.

Tucked deep into the tectonic folds of Zanzkar, these monastic villages have become part of the geology; indeed, the settlements are often situated in a specific location because the terrain is believed to be holy and to contain mythic/mystic qualities. The edges of precipices and the confluence of streams, products of both tectonic uplift and erosion, are especially revered in the Buddhist faith as places of power. They are auspicious sites for the placements of temples, whose presence, in turn, further sanctifies the place. In this way, Buddhism in Zanzkar organizes the landscape into a grand cosmologic cycle that uncannily mirrors the counterpoised forces of the geological cycle.

It's not surprising, then, that the rituals of monks and farmers living in Zanzkar should be in accordance with geographical phenomena. Valley breezes, ushered in by dramatic changes in the topography, insure that the prayer flags hanging high above the temples flutter nonstop, sending merit to heaven without interruption. The devotional chanting of the monks mirrors the moaning sound of the mountain wind. Villagers cultivate soils made productive by the deposits of river sediments and then divert glacial run-off to irrigate the farms. Fast-flowing streams spin the paddles on huge, copper prayer wheels, or turn the millstones that grind barley into flour in the water-wheel houses. And among the remnants of the Tethys Sea are the treasured ammonites, believed to be sacred *mandalas*, whose spiral patterns represent the

cosmos. So important are the universal qualities ascribed to this maritime relic that it occupies a place of honor as the "Eye of Wisdom" on the broad forehead of a ten-meter (thirty-three-foot) tall golden Buddha enshrined in the Thikse Monastery in Ladakh.

Cultural life in Zanzkar embraces the geological origins of the mountains in myriad other ways: prayers chiseled into stone tablets set along pathways; caves used by hermits and yogis for meditation; rocky outcrops providing platforms for "sky burials" (where the bodies of deceased persons are hacked up and fed to vultures in a reverential act of unity with nature); sacred songs and dances that recount the receding waters of a great primordial sea; demon-filled tarns and high passes guarded by benevolent fairies known as *dakinis*; images of gods and saints rendered in the striations of a cliff or the silhouette of a mountain. Taken alone, these may represent any one of a number of local beliefs but, together, they compose an entire worldview, one that unabashedly mixes elements of both geology and faith into an alchemic bath.

I broke camp early the following morning. The delay at the pass had proven fortuitous; it had provided me the chance on the prior evening to watch a herd of blue sheep (called *bharal*), nimbly pick its way down to the stream near my tent. It was dusk, and their blue-gray shapes blended into the boulder-strewn slope so that I almost missed them. I heard rocks sliding down a hill where they jumped over gullies, but it took awhile for my eyes to recognize their silhouettes against the hillside. The animals slowly approached the bank, where I crouched nearby behind a boulder. Elsewhere in Zanzkar I had come upon the bharal, but never before had I seen so many in a herd, nor so close. I watched the animals until it became too dark to see and then returned to my tent, my movements putting the herd to speed. I was amazed at how quickly they fled through the black and rough terrain. With darkness in full descent, the flight of the sheep reminded me that I was in the lair of the secretive snow leopard, which preys on the bharal in their rugged habitat near the snow line.

For several hours that morning I followed the stream through a deep gorge, walking among astonishing formations of eroded earth that appeared like stalagmites reminiscent of the famous ruins of the ancient Tibetan kingdom of Guge located near Mount Kailas. Occasionally, I came upon willow groves that were a delight to see after so much time in a countryside devoid of

trees. I took notice, first, of their greenery, vivid against the drab hillsides and, then, of the bright scent of leaves. The branches waved in the wind against the rocky background and were a hopeful sign that I would soon depart the barren landscape of Zanzkar and enter the slightly more hospitable realm of the Indus Valley in Ladakh. I stopped at one of the groves to rest and eat in the shade, delighting in the musical sounds of the rushing water and in the chirping and flitting of birds in the foliage.

A few hours more of walking through twists and turns in the narrow gorge brought me to the head of the Stok Valley, where several tributary valleys joined and opened onto a broad sweep of land that gradually fell away to the Indus Valley. I noticed a familiar-looking horse grazing in a nearby pasture. When I got closer, I saw from its disheveled appearance and the duffel bags askew on its back that it was the runaway pony from the pass. It had managed to find an alternative route down to Stok via a side canyon. Not knowing what else to do, I secured the packs onto the horse, grabbed its reins, and led the animal along the trail into the village.

Fields of barley covered the land around the village, and farmers were busy attending to the harvest. I heard them hoot and holler to one another and yell commands to their livestock. Small clusters of men and women gathered around the threshing plots, where yak, tied to a post, tromped on the harvest as they walked in endless circles, crushing the grain with their heavy hooves to loosen the hulls. The residue was raked into piles, and women with pitchforks threw it high into the sky, allowing the wind to separate the grain from the chaff. The men cussed at the yak as they drove them in tight little circles, and the women sang to one another and whistled to call the wind so that it might blow steady and ease their work.

I walked up to a family engaged in this work. They greeted me curiously and looked at the horse I was leading toward them. I introduced myself and explained the presence of the animal, recounting the previous day's events. When asked, they replied that they didn't know who owned the horse and refused to take responsibility for it, explaining that, if something was missing from its load, they might be blamed by the owner for a theft. I told them I could hardly be expected to continue my journey with the unclaimed horse and that I, too, no longer wanted the burden of it. We were at an impasse, and they suggested that, since it was time for dinner, I should sit with them and eat, and we could talk more about it.

A blanket was spread on the ground in the middle of a field, and one of the daughters served steaming bowls of meat stew, peppered and seasoned with spices and filled with vegetables, potatoes, and barley. I sat and ate the delicious food, gazing across the valley to the village, conversing with the people seated around me, and thought what a nice spot it was to be. The late afternoon sun was still warm. A slight breeze stirred the grain in the fields, and the towering rock walls of the valley glowed with an interior light, as if the magma hadn't altogether cooled deep within earth. We finished our meal and, despite much discussion, were no closer to solving the problem of the abandoned horse, when an old man strode toward us with an expectant look on his face. He had spotted the horse with our group and came over to greet us.

In a quick, matter-of-fact introduction, the old man explained that he was the owner of the horse and father of the boy I had met at the pass, and he had come to retrieve his animal, knowing it would find its own way down to the village. The family asked the man to sit and eat, but he declined, explaining he had to get back to his camp below the pass. The man inspected the pack and found it intact—which relieved my companions—and after a few more words started back up the mountain trail. In parting, he said he could reach the camp before it was dark, if he hurried. The man was toughened by the Himalaya, long accustomed to its terrain and the rigors of a mountain trader's life. He was at least seventy years old and would cover in a couple of hours the distance it had taken me most of a day to traverse.

The caravans that cross the Himalaya rely upon natural corridors of travel that are shaped by tectonic events and erosion, crossing passes between the high peaks and following rivers that cut deeply through the range. In Zanzkar, the paths traverse an especially desolate and empty terrain. The trade routes are difficult and often treacherous and in bad weather can be impassable. Yet they have connected distant places throughout history and still serve as lifelines between remote settlements and the outside world. Meanwhile, the farming villages occupy meager land that is relatively flat and near water. Such places are few and far between, and the communities they support are bare bones, relying a great deal on faith and hope to survive. The monks who build monasteries in these places see them in a religious light.

In such ways the mountain topography is understood beyond its geological components. Whereas scientists may study the tectonic structures of the

Himalaya with an eye toward better understanding the forces of mountain-building or to discover minerals to predict earthquakes, or, most recently, to monitor the impacts of climate change (global warming) on the alpine glaciers, native people have a practical and immediate reason to know the mountains: they constitute the physical platform upon which people live and, thus, in a most literal way, occupy the stage of their life, wherein they find both livelihood and a sacred promise.

The tectonic history of the Himalaya, with its uplifts, thrust faults, and suture zones, has produced the highest mountains in the world—alternately dazzling and terrifying, widely acclaimed, and well outside the reach of most people. Only the world's most brazen mountaineers venture onto their summits and in so doing admittedly enter the "death zone." Some of the alpinists speak of "assaulting" the mountains, as if such a thing is plausible. Most climbers, though, admit that the desire to pit themselves against such a formidable challenge is rooted mainly in quests to discover better who they are as sentient human beings.

Some native people also have taken up mountaineering, serving as guides and porters to the foreign expeditions in order to make money, but most simply can't imagine climbing the high peaks. They are sacred, after all, and to touch the summit of such a mountain would defile it. People may live within sight of the white peaks but not wish to conquer them, content instead with surviving in the alpine worlds by balancing their humanity against the seismic power of the mountains. It is this abiding drama of humankind fashioning an existence among the seismic folds of the Himalaya, offsetting adverse geographical circumstances with cultural ingenuity, which is one of the most mesmerizing stories of the range.

LIFE IN BALANCE

(Phalabang, Nepal: 1984 and 1985)

O N THE EVENING OF THE FULL MOON, in the first month of
spring, I joined a group of priests on a climb through oak forests toward a hilltop known as Tharkot. The summit lies above the village of
Phalabang in western Nepal, where I had been living for much of the previous year. The priests were also farmers, and I knew many of them quite well
as neighbors and from my research work in the settlement. It was a slow time
in the farm calendar, after the harvest of the winter grain and before the monsoon planting, and our hike to Tharkot provided a short break from the tedium
of village life. The priests had specific and pertinent business at hand, but, for
me, it simply was a chance to explore the ridges that loom high over the village.

The climb took us the better part of a night. Upon reaching the summit, the priests walked in the moonlight along a forest path to the ruins of an
old temple. Rotting timbers lay strewn about, and a crumbling brick stairway
marked the remains of a pavilion and courtyard of a once-ornate structure.
The forest had overgrown the site, so it was thick with plants, and the air was
filled with the sounds of the woods—rustling dry leaves, cicadas, macaque
monkeys, and night birds. In an enclosure formed by a wall of hand-cut stone
and protected from the wind, the priests set up camp under the shade of a
strangling fig tree. Over the next two days they would pray for rain.

The view from the Tharkot summit took in much of Phalabang's surroundings: scattered clusters of homes marking the satellite villages where
different clans lived, fields and pastures, upland forest, and the terraced rice
fields straddling the Sarda River located a mile below in the distance. Beyond

all that was a succession of ever higher ridges, which dissolved like a water-color painting against the indeterminate northern horizon. Excepting the rice terraces located in the Sarda Valley, where water from the river keeps them green throughout the year, the preceding two months of post-winter drought had given the land a brown and withered look. Peering down upon the desiccated scene, knowing it would all change and become lush again in a month or so when the monsoon commenced, there was cause for reflection: what would happen if the summer monsoon rains failed that year?

It was a good spot to petition the deities for a bountiful monsoon. Life in Phalabang pivots tenuously on the hinge of the seasons, moving from dry to wet months in a grand, synchronistic sweep of plantings and harvests. The prayers at the temple were meant to elicit the help of God in making the transition from one growing season into another, rather than leave it solely to the chance of the weather.

The view from high above Phalabang showed a manicured landscape of productive farm terraces fed by irrigation ditches and interspersed with patches of forest where fodder was cut to feed the livestock—a place of human design and proportion. Even with the barrenness brought on by the seasonal drought, the scene was prettily sketched. Adobe-and-thatch homes blended nicely into the terra cotta-colored earthen scene. No industrial monuments marred the view, nor plumes of chemical smoke, roads, or toxic landfills. Here, it seemed, was a place much as it has always been, where people might live in accord with known environmental boundaries, a harmonious place kept so by the hard work and religious practice of its inhabitants.

Signs of stress, though, could be observed in the landscape, if one had the inclination to look for them. Gullies formed where the soil eroded, leaving scars on the slopes. The trees took a skeletal form with much of their foliage and branches removed for firewood and animal feed. Tiny agricultural plots plunged down slopes much too steep to till safely. Stream beds and springs that once gushed water now ran intermittently—telltale signs of an order out of kilter. The panorama, so pleasing to look at, contained the very seeds of decay that sprout across many parts of the Himalaya, where the excessive demands of modern society have disturbed the ecological balance. The decline reached the most remote spots, places such as Phalabang, forever changing peoples' lives and their association with the land.

The farmer-priests in Phalabang sought the aid of the deities atop Tharkot not only to insure the proper timing of the monsoon, otherwise a mere meteorological event, but also to counter the more egregious effects of human society. The pressures of a burgeoning population have intensified greatly, and the management of village resources—rivers, springs, forests, and farms—doesn't always work well or to everyone's benefit. Some of the springs in Phalabang have completely dried, and the streams are becoming polluted in ways that remove them from safe human use. Each year the villagers spend more time collecting fuel wood and fodder, more soil washes away, and the productivity of the farms further decline. Meanwhile, the modern world extends its reach further into the mountains, competing with local people for resources and doing its own environmental damage. Attributing such changes solely to the whim of gods denies the follies of humankind. I discovered that the priests atop Tharkot understood that—they prayed not only for the benevolent intervention of supernatural forces, but also for guidance to a balanced approach in village life.

During the 1970s and early 1980s, warning bells had sounded throughout the scientific world of an impending ecological crisis in the Himalaya. The number of people living in the mountains more than trebled between 1950 and 1980, and it was believed that the high rate of population growth had surpassed the carrying capacity of the alpine environment, that the runaway commercial extraction of resources contributed further to its demise, and that life in the mountains was out of balance. Reports also emerged in the popular media about farmers caught in a desperate struggle for survival: forced to cultivate ever-steeper and less-fertile slopes, travel further in order to locate sufficient fuel for the cooking and heating fires, and to wait longer for water at village springs that had dried to a trickle. Precious topsoil, lost to the erosion when the forests are cleared, made its way through the Himalayan watersheds to India as one of Nepal's unrecompensed exports. As a result of these trends, reports indicated that human poverty was on the rise almost everywhere in the mountains.

That such a plight could inflict the Himalaya, where people had lived for many centuries, was an unsettling idea both for its inhabitants and for people around the world who felt an affinity toward the mountains. It was

a harbinger of further impoverishment and a violation of the immutable nature of the mountains. Moreover, because the environmental conditions in the mountains are closely tied to those on the adjoining plain, the spiral of degradation in the mountains was thought to have spun out-of-control onto northern India and Bangladesh.

In this view of things, floods on the rise in the lowlands are blamed on degraded conditions among forests in the high Himalaya. The mechanisms are complex, but put simply, soil eroding from the steep slopes fills the rivers, which then surge unpredictably down the valleys, washing away land, livestock, and village houses. The upland farms become less productive and the valleys more dangerous places to live, and life becomes generally more tenuous for everyone. Not only are the people in the mountains deeply affected by all this, but also those living on the plains of India, Bangladesh, and China. And the culprits of this disorder are reported to be the mountain farmers, whose sheer numbers had somehow overwhelmed the carrying capacity of the Himalaya.

Although logical, this scenario is fundamentally wrong. More people in lowland Asia are suffering from floods because more people live near rivers, which flood naturally. The highland farmers are not so much the culprits of ecological disorder as they are the victims of it. And the primary force behind landslides and erosion in the mountains is not human society but the pull of gravity. Nonetheless, the intellectual satisfaction of the doomsday scenario was great enough that a number of startling reports of imminent ecological collapse in the Himalaya appeared early on in the world media. Eric Eckholm's influential book, *Losing Ground* (1976), predicted the makings of a great human tragedy. The documentary film, *The Fragile Mountain* (1982), by Sandra Nichols depicted in beautiful and haunting images the desperate straights of farmers living in Nepal. Illustrated reports filled newspapers and magazines with the ironic juxtaposition of beauty and despair. *Newsweek* reported in 1987 that, with the current rate of deforestation, the Himalayas would be bald in twenty-five years.

Meanwhile, hundreds of millions of dollars in foreign aid was funneled into the Himalaya to remedy the situation, creating an entire cottage industry of environmental consultants and aid workers in Nepal and elsewhere. Much was debated and much was at stake concerning the true nature and magnitude

of the problem. A number of theoretical books were written about the environmental degradation. It was a heady time for those who saw ample cause for gloom and doom in the Himalaya dilemma.

Armed with this bleak outlook, I settled into Phalabang in order to examine the local circumstances of the Himalayan problem as my dissertation topic. There, among the farmers, some of whom also were priests, I found life in a precarious but not unusual state of affairs, where some places exhibited the dire conditions forewarned in the media reports and others showed a remarkable cultural resilience and a stalwart adaptation to the natural environment. At first, as a young person still in graduate school and lacking confidence, I simply sought to provide more currency to the prevailing alarmist point of view, rather than to imagine something different. Consequently, I focused my attentions on the supposed problems in Phalabang, rather than on the ways in which villagers sought to address them or whether problems of magnitude even existed at all in the village.

Eventually, with time and reflection, I came to understand that no single description of the Himalaya can ever capture its complexities. No generalized theory will account for its enormous diversity, even in a place as tiny and circumspect as Phalabang. And, therefore, no overarching policy could ever hope to address it. Instead, I came to understand that equanimity is possible in the midst of a growing crisis and that academic theory not anchored in the ordinariness of life has limited value. Those were the lessons I learned in that remote Himalayan village. I imagined, too, that, if one could say anything helpful at all about environmental conditions in the Himalaya, it might only be that people cope with problems in myriad ways and make thoughtful changes in their lives and surroundings accordingly—to both good and bad effect.

That kind of thinking, though, is not what the community of scholars and development people sought. It told them nothing, for example, about what they might do, or how to spend their money, and provided no theoretical abstraction for further academic study. It assumed that people already know what they are doing. With follow-up studies, it became clear that the best arrangements for sustainable life in the Himalaya may already be practiced in the mountain villages and that those seeking to promote new developments in the mountains might do well to look at what already exists before thinking up something new.

For three days I remained atop the Tharkot summit with the priests. We slept in the open air on our pads under thin sheets of cotton and ate simple food—rice and lentils washed down with clay jugs of watery yoghurt. The nights were warm and clear, filled with stars that hung so low in the sky they seemed to be just out of reach. Dawn filled the sky with a rosy glow, as if the place heralded the morning of the world, the days grew oppressive in their heat, and the twilight lingered far into the evening.

The forest was loud, even at night, restless and impatient with sound, crackling in its dryness. A breeze arose in the afternoons, rustling the blades of withered grass and the dry leaves of the forest, but provided little relief from the heat. The wind came from the south, from the baked plains of the Ganges Basin, and, like an advancing electrical charge, it brought the sweltering heat of India to our tiny hilltop encampment.

The priests seemed oblivious to the discomfort, lost in their meditations. During the long, hot afternoons, I sought the shade of trees and strived toward a stillness to slow my breathing and offer some relief but felt as if I were afloat in a pool of humidity. Puddles of perspiration dampened my clothes and attracted flies, which alighted on my face to lick the salt from my sweat. Mosquitoes buzzed loudly. It was impossible for me to remain still, while the exertion of swatting bugs only increased my misery. Meditation such as the priests practiced was out of the question for me.

Meanwhile, all through the days and late into the nights, the men prayed. They chanted, rang bells, and read from ancient scripture. Incense burned constantly, its scent wafting in the breeze and adding to the other odors of the place—the smell of dry grass and leaves, livestock droppings, occasional wafts of hashish, and wood smoke drifting up from homes located far below in the valley. The priests sprinkled holy water on the ground, which greedily sucked in the tiny droplets, and they flung more water into the sky, where it instantaneously vaporized. The men sat cross-legged on the ground and rocked back and forth, swaying their cotton-clothed torsos in time with the chants and bells.

When I got impatient with the priest's rituals I went for walks. These took me through the forests atop the ridge, where I came upon cattle, buffalo, and goats grazing among the open trees. The animals had cleared the forest floor with their grazing, devouring just about every green plant, and

their tromping about had compacted the soil so that little grew beneath their hooves. The clay soil hardened to concrete. There was little chance for tree seedlings and herbaceous plants to take root in the bald ground, and the native forest, remarkable elsewhere for its diversity, could not hope to regenerate. Only the hardy Chir pine, evolved to deal with the stressed conditions, thrived. Even so, its needles provided little fodder for the livestock, so that the animals grazing in the forest grew thin from hunger and their incessant march in search of food.

I met people in the forest from Phalabang, and occasionally from other more distant villages, gathering firewood and animal fodder. Women and children did much of this work, foraging among the trees for the fallen limbs and twigs or cutting fresh branches, following the faint trails in the wood that led between settlements. When they called out to one another, their voices rang in the air with startlingly effect: "Younger sister, older brother!" they called, "This way. Come on, let's go!" The wood gatherers stooped low beneath the weight of their baskets and were hidden in the foliage, so that the twigs and branches of their overflowing loads appeared to move about as if of their own volition. The children carried smaller versions of the burden baskets and roamed in packs among the trees, sneaking periods of play and games into the workday.

In a few places, I found large empty swaths where trees had been cut on a commercial scale, creating holes in the forest through which I gained glimpses of the Dang Valley located south of the ridge. Numerous fast-growing towns in the valley placed high demands on the timber above Phalabang, and their commercial extractions competed with the subsistence harvests of the villagers. The result was felt across the forest, which had deteriorated to an alarming state. The canopy was sparse in many places and the understory of young trees almost nonexistent. The rich complexion of species found in more remote forests was nowhere to be seen on the ridge. My perambulations from the Tharkot temple traversed a landscape that, from a distance, looked rather ordinary but, upon closer inspection, revealed a deeply disturbed state of affairs.

The forests of Nepal first began to show signs of stress during the latter half of the twentieth century. It was due, in large part, to the increasing population

of the country but also to intensified commercial logging, which had grown commensurate with the development of lumber markets in Nepal and India. The mountains are a valuable resource frontier for the Himalayan countries, and, in the case of Nepal, the Kathmandu-based government put early effort into making the forests more accessible for economic development. Other infrastructures quickly followed: roads built by Chinese and Indian engineers to open zinc and copper mines, new settlements along the roadways, and rivers dammed for hydro-electric power, among others. A few persons, mainly the large-scale entrepreneurs and some politicians, became wealthy off the resource extractions, but most villagers are further impoverished by them.

Satellite imagery and government forest surveys show a rate of forest loss in Nepal at the turn of the twenty-first century in the range of one to five percent a year. The most serious depletions occur in the southern zones of the country among the foothills, on the piedmont plain, and in the more accessible parts of the central hills, where the majority of people live. These places gained early access to the roads, towns and villages grew quickly, and the forests were first and hardest hit by the timber-cutters. The trees in the remote western districts of the country, where Phalabang is located, were spared the earliest phases of excessive extractions, but that now has changed.

Fuel wood and fodder needs continue to rise, and commercial cutting is on the upswing, so that, on average, the land cover in Phalabang provides less than a quarter hectare of forest for each person. This simply is not enough to meet basic needs. As a result, the villagers use the forest more intensively. To the south of Phalabang in the Dang Valley, the conditions are even worse, and it's easy to see why. Hardly a swath of forest remains intact in the valley. Large-scale timber barons have put the forest to axe. The remaining ragged clusters of forest have been so heavily lopped for fodder that, in some places, they are mere outlines of trees, skeleton-like in appearance with knobby protrusions where branches once formed a canopy. I regularly crossed the Dang Valley on my way to its trading centers and often observed the sorry state of forest affairs. It seemed only a mater of time before all its trees would be gone. The timber goes to industrial towns, and the soils fall to the plough, thereby following a trend that has been established across much of lowland Nepal.

The southern tier of Nepal opened to the rest of the country only in the 1950s, when the endemic malaria that kept settlers away was contained by

extensive DDT-spraying. Before that only members of the indigenous Tharu tribes, who had acquired immunity to the mosquito-born disease, lived in the dense forests. The Tharu lived a nomadic life, subsisting on wild game and edible plants gathered in the jungle, and their settlements were widely dispersed across the region, so that little pressure was felt in the immediate forest. During the 1970s and 1980s, following the successful mosquito eradication campaigns, people from across the steep hills of Nepal settled into this region, cleared land, and built homes. The immigrants pushed the Tharu tribes deeper into the jungle, where they now contend with marauding wild elephants, rhinoceros, and tigers invading their impoverished villages.

During the late 1980s, Himalayan scholars began questioning journalistic claims about a spiraling rate of ecological collapse, citing new evidence that suggested it was not as severe as once thought. An ensuing controversy emerged, fueled by the large infusions of foreign aid. There was a lot of money to be made in such a doomsday scenario. The emerging scientific consensus pointed to seismic energy and the force of rain, rather than human mismanagement, as the real culprits behind the problems of accelerated soil erosion and landslides in the mountains. Others disagreed. For many, excited by the controversy, the biggest environmental challenge in the Himalaya was, in fact, the very uncertainty of its landscape.

In the afternoon of the third day of prayer, it was time to leave the Tharkot temple. The priests packed their belongings and returned to Phalabang, descending quickly in order to reach the village before dusk. I left the group at the outskirts of the settlement and made my way to a farmhouse, where I had taken lodging. My room was on the second floor, above the livestock quarters, so that it reeked with the warm odors of barnyard animals and roof thatch. It wasn't a bad place to live, despite the stench, and it was a decided improvement on my earlier quarters, which had been a tiny mud dwelling carved into the side of a hill. The move to new lodgings was prompted by the discovery of a cobra skin shed just outside the doorway of the prior dwelling.

The farmhouse was situated on an earthen bench amid a cluster of grain fields, which made it convenient for my work with the tillers. The view out the tiny second-story window took in much of the landscape of Phalabang. I was studying the way people manage local resources—soil and water for

farming, thatch, firewood, and fodder collection in the forests. I thought that, if I could properly document the ways in which the villagers in Phalabang go about managing nature in their daily lives, I might better understand the generalized impacts of mountain society on the Himalaya environment and, perhaps, identify signs of stress where they occurred elsewhere in the range.

As I look back on it, my study was both overly ambitious and naïve. I was much too simplistic to conform to the prevailing notions of an imminent environmental collapse, and the questions for which I sought answers were too large for the circumscribed format of my study. Nonetheless, it was interesting work and occupied my time.

My study took me into the fields, where I observed farmers, or into the forests, when I traveled with plant gatherers on their hunting expeditions. My neighbors regularly stopped by my lodging to chat, drink tea, and otherwise pass time, which gave me ample opportunities to interview them and to collect the various types of information I sought about village life. I took measurements in the fields and forest—soil movement and the size of landslides, tree diameters, species, and the amounts of time people spent on certain activities. I conducted a livestock census. I weighed bundles of fodder and firewood.

The focus of that effort was this: I saw a link between the state of the forests and the productivity of the farms, both of which were in reported decline in Phalabang, and thought that the cycling of nutrients between forest and farm held the key to sustainable village life. Manure from the grazing livestock in the forest provided fertilizer for the agricultural fields, supporting the crop yield, and ultimately a stress in one would transfer to the other. As I saw it, the nexus of the system lay in the way people go about the business of managing both forests and farms to a singular effect. Simply put, it was about animal dung and survival. My research sought to discover the exact components of the forest-farm linkage in Phalabang and to measure its vitality against the recent changes in Phalabang's geographical circumstances: demographic and economic pressures were on the rise in the village, while the state of the environment was reportedly in decline.

Furthermore, I thought the village might serve as an apt metaphor for life throughout Nepal and, indeed, the entire Himalaya, and so the importance of what I was doing became inflated in my mind. At that time the entire

range of mountains, except those places so utterly remote as to be virtually inaccessible, were caught up in a slow, inexorable drift toward modernity. The global economy had penetrated the alpine fastness with surprising alacrity given the rugged terrain. Villages everywhere were moving from subsistence life to commerce, focusing on future markets for opportunities, rather than on the land and the past for guidance, and embracing the kinds of technological and societal innovations that come with all that.

Initially, I thought that, with my selection of remote Phalabang as my study site, I would examine a place caught in the past. But I discovered, instead, that I had entered a village on the threshold of profound transformation. I became concerned with disentangling the threads that wove new patterns of life in the Himalaya. I noted, especially, how commerce and subsistence collided in such places and ultimately deconstructed my earlier thoughts about a village out-of-balance.

It was not exciting work much of the time. Endless hours were spent observing people at work. That was a suspect thing for many of the villagers, who don't give much analytical thought to what they are doing—it is simply natural for them to do it and a logical extension of their lives. They thought, instead, that it was curious I didn't already know the things they took for granted, as if I lacked good common sense. The work of a geographer in a mountain village contains long gaps of idleness between observation and documentation. At times I thought the villagers simply wondered why I didn't have a real job. I remember reading about an anthropologist somewhere who had asked a village elder how she might best help out in the community. The woman's reply: "Stay at home and go to work."

My occasional attempts to actually do some of the farm work I was studying elicited mainly bemusement among the villagers. Strapped to a team of stodgy oxen pulling a wooden plow, I'd cut zigzags and swirls through a field, rather than straight lines, and my tentative pulls at a water buffalo's teats drew puzzled snorts from the animal and laughter from the children who normally do that work. Although my childhood was spent among agrarian relatives in the American Midwest, clearly I hadn't much to offer the Himalayan farmers. My village neighbors, though, welcomed me into the fields to help with the work, even though they quickly learned to have little confidence in my abilities to do so.

The amount of farmland in Nepal increased dramatically during the latter half of the twentieth century as people cleared more forest, but still it has failed to keep pace with the growing population. Some of the land degradation I noticed in Phalabang early on was a result of this growth. In the western hills, each meager hectare of farmland—less than three acres—must support four persons, and, as a result, the region around Phalabang is a food-deficit area, requiring heavy imports of food to stave off malnutrition. An exodus of people from the region began in the early 1970s in response to the food shortages, and, with political unrest and a lack of government services, it has only gotten worse.

Seasonal or yearly fluctuations in food have always been a part of the tenuous nature of life in the Himalaya. Farm productivity waxes and wanes across the years, reflecting conditions of weather, land, technology, and mountain society. What is different now is the persistence of shortages. Today, there are simply no new places to cultivate, and farmers must use the existing land more intensively or leave the village. The size of the fields grow smaller as they are carved up and inherited by successive generation of a family, until they become so diminutive as to be almost worthless. Meanwhile, commercial resource extractions continue to accelerate, making solutions to the dilemma of how best to sustain village life all the more elusive.

Shortly upon returning to Phalabang from the Tharkot summit, the priests who had conducted the rain ceremony met with the other village farmers to discuss the timing of farm work. It was nearing the season for field preparation in advance of the monsoon. The winter wheat crop was harvested, and the fields lay fallow. During the previous month, the farmers had made a special effort at collecting livestock dung from the forests. Women and children roamed by day through the trees with bamboo burden baskets to gather the cattle droppings that had dried on the forest floor. The dung loads were brought back to the village and piled into courtyards between the homes.

Now it was time to move the dung piles onto the fields, and everyone, including me, pitched in to help. The farmers hauled the manure to their terraces, where women and children using crude wooden rakes mixed it into the mounds of plant materials that already lay drying on the slopes. One hazy day, in blazing synchronicity, the compost mixtures everywhere in the village

were set afire. Acrid smoke filled the air with a pungent, sweet odor. The dung piles smoldered for days, until nothing remained of them but heaps of gray ash. When these cooled, the farmers raked them across the fields and ploughed them into the soil, releasing nutrients to the dirt, thus closing the loop between forest and farm.

The farms in Phalabang are located on steep slopes—some greater than forty-five degrees—and require constant upkeep in order to hold them together against the relentless force of gravity. The farmers design their fields to halt the slippage of earth, planting buffers of small trees and shrubs to catch and retain the soil, repairing rents and leaks in the irrigation canals, and building stone walls to retain the terraces that continually threatened to slide away. It's rigorous and sometimes dangerous work—farmers are reported to have been killed by falling off their fields.

Not all fields in Phalabang are equally productive. Soils vary in organic content, and the angle of the sun determines how much energy a farm receives during the course of a day. These factors shift kaleidoscopically amid the diverse landscape so that, with an imaginary turn of a dial, a farm may be either blessed with fertility or plunged into shadowy darkness and thin soils. I moved often among the various settings, marveling at one extreme and alarmed by the other, recognizing in both the measures of a harmonic pendulum swinging between hope and despair, good land and bad, a matter of timing or the moral predilections of human society.

In their tectonic struggle with the geography of the Himalaya, the Phalabang farmers have carved the entire mountainside into cascading fields of rice, wheat, and corn. The farm terraces exceed a mile in vertical relief, dropping one onto another to span the distance from mountain top to valley bottom, all bound to the laws of gravity, directing the flow of water and engaging the labors of villagers through generations. How one person manages a terraced field will determine the survival of all others in a domino-like chain of cause-and-effect.

My work in Phalabang eventually led me toward a fuller comprehension of just how difficult it is to live among such geographic extremes. It's a matter of faith for the farmer-priests, who placate their deities atop Tharkot. Village life extends across a wide spectrum of natural and supernatural possibilities, but much of survival simply involves persistence and hard work. Life on the

edge of the mountains is, indeed, precarious; that is another lesson I learned while living in Phalabang.

My study, though, sought also to extend the circumstances of the village to a larger profile of the mountains. Toward that end, I thought it might be useful to explore regions at some distance from Phalabang, noting the terrain and the quality of the farms and forests elsewhere in the hope of coming up with some notions that might helpfully set the tiny village into a bigger picture.

An American forester, who was posted in a village near Phalabang, made regular forays into the northern mountains as part of his work assignment. We occasionally got together for meals, and one evening he inquired whether I'd like to join him on an extended trek into the remote upper regions of the upper Bheri River. He said he could use the companionship and explained that we would cover 650 kilometers (400 miles) of rough trail and pass among dozens of villages that saw few, if any, outsiders. The trek sounded appealing, not least because it would provide a chance to get further into the high and wild places of the Himalaya. We made plans to leave on the following week.

Our journey began with a series of pleasant walks along a ridge to nearby villages, where the forester inspected tree nurseries and discussed plantings with the farmers. The condition of those places closely resembled that of Phalabang, and the landscape showed a familiar mix of farm terraces, stucco-and-thatch homes, and pasture for livestock. As we headed north, though, the terrain grew steeper and rocky, and the settlements became sparse and more impoverished. The cultivated land gave way to grassland and forests, and people, in turn, became agro-pastoralists, moving with their herds to high pasture during the summer months. We entered the isolated villages of the Magar tribes, who greeted us coldly and with suspicion and only reluctantly provided us with food and places to sleep. The high, snowy mountains loomed ahead of us—sentinels of another kind of place. The trail was cut into vertiginous cliffs, with the river raging far below, so that, in the narrow spots, it was treacherous to walk.

Within a week's time we left behind entirely the Hindu world of the middle hill farmers and entered the Buddhist highland villages, where the inhabitants speak a Tibetan dialect, raise barley and potatoes on scrubby little

fields, and herd yak in the pastures located beneath the glaciers. The rough villages were clustered around imposing monasteries and surrounded by barren terrain. It was hard to imagine how people eked out a living in many of the places we visited. The forester wanted to inspect some of the old trees that grew at the high altitudes, and I used the time to wander about the cold villages. They had a fascinating cloistered architecture, adorned with animal skulls, flags, and clay figurines, and their medieval aspect seemed appropriate to the harsh surroundings. I felt a world away from Phalabang.

On our return trek, the abrupt changes in the landscape made it seem as if we literally were sliding down the southern slope of the Himalaya. The transition from highland to low elevation was made in broad steps, each lasting a day or so: we first passed through cascades of blocky terrain that were cut by rivers and then descended slowly along tapering ridgelines until, a week later, we finally eased back into the hills and a more temperate climate. We could feel the profile of the Himalaya in the track beneath our feet as we trekked south.

It is no wonder that the majority of people in Nepal live among the gentler contours of the middle hills. The highlands simply cannot support much life. Their attraction lies in the lofty and austere summits and in the intimate way the craggy landscape cradles the small, scattered pockets of human life. But the high altitudes lack the coziness and green fecundity of the middle hills. As difficult as the world may be for the hill farmers, the odds of a balanced life are a bit better in villages such as Phalabang.

THE PURSUIT OF HAPPINESS

(Bhutan: 2004)

A GATHERING OF INTERNATIONAL ECONOMISTS in 1987 heard the King of Bhutan proclaim, "Gross national happiness is more important than gross national product." One can only imagine the eyebrows lifting among the more staid development experts. A Western news correspondent dispatched the remark, and it was broadcast by wire services worldwide in stories with the populist banner, "Bhutan's Happiness Quotient." The king's idea, at first, was considered intriguing, perhaps even wise, but not a practical basis for national governance. It conjured utopian images that are anathema to politicians and, despite the initial curiosity it had piqued among people around the world, was soon forgotten.

Thirteen years later, though, the members Bhutan's Planning Commission wrote a report, entitled *Bhutan National Human Development Report 2000*, which formally proposed the king's notion of happiness as the official yardstick for measuring success in the human development of the kingdom. Happiness became enshrined in government policy, the country's legal affairs, and the rhetoric of politicians and religious leaders alike (in Bhutan, the two often are inseparable). It became the unifying theme for advancing the kingdom's cultural and natural heritages beyond philosophy and into the hardball courts of economic decision-making and social governance. And it catapulted Bhutan further into the world's geographical imagination: Could this tiny Eden-of-a-country, blessed with natural abundance and ancient cultures and now with happiness as its explicit goal, show the way toward a sustainable way of life for the societies of much larger and more prosperous nations?

In so many ways, the kingdom is an enigma, and so it may not be so strange that Bhutan embarked on such a road to the future. The country contains less than 47,000 square kilometers (18,150 square miles)—smaller than Switzerland—yet it holds one of the richest assemblages of life species on Earth. It's known in its own language as Druk Yul, "Land of the Thunder Dragon." The national flag of Bhutan shows a white dragon crossing a field of yellow and orange. The dragon holds a jewel in its claws. The national emblem is a diamond thunderbolt hovering above a lotus, surrounded by dragons, symbolizing the reign of purity and spiritual power. The national flower is the rare and beautiful blue poppy (*Meconopsis grandis*), the national bird is the raven—associated throughout the Himalayan world with deities and demons—and the national animal is the bizarre and endangered takin (*Burdorcas taxicolor*). The latter is a bovid mammal living furtively in the mountain forests and looking much like a whimsical assemblage of body parts taken from other large animals, put together in haphazard fashion.

Combined, the eccentric emblems of Bhutan are symbolic of the nation's personality, and one is struck by the sense of proportion and balance that permeates them—even with the ungainly takin—and the people's reverence for a much larger, interior sense of geography. Indeed, the very underpinning of life in Bhutan is upheld by precepts that emphasize religious devotion and a healthy respect for the natural order of things. These predilections stem from the country's Buddhist background, especially that which links human existence to cosmic alignments.

Perhaps for Bhutan, where contentment has long been at the heart of individual striving, the notion of happiness as a government ideal is not so far-fetched. It would seem to be based on the kingdom's oldest traditions. The concept, though, also holds appeal for people living outside the kingdom, especially in the highly industrialized and urbanized West. Outsiders look upon Bhutan as a sort of modern-day spiritual warrior, a quixotic hero of tiny but epic proportions who is committed to a journey that crosses the divide between sacred and profane worlds. In taking this path, Bhutan eschews the pitfalls of the consumption-centered model of growth that afflicts most modern societies in the world. Rather than becoming rich, the monarch has expressed his desire that the subjects of his kingdom be happy.

Not everyone in Bhutan, though, is happy as a lark. Many people think that the nation's approach to happiness places the well-being of its dominant culture, the Drukpa, above that of its minorities and that the human rights and choices imbedded in the Happiness Idea are not truthfully extended to all people. At the extreme end of this, during the early 1990s Bhutan evicted almost 100,000 people of Nepalese ancestry who'd been living in the kingdom since at least the early twentieth century, suggesting they were not legal citizens in the country. They live now in refugee camps in Nepal, with little hope of returning to their homes in Bhutan, facing an uncertain fate arbitrated by diplomatic forces and suffering the universal plight of a disowned people.

The refugee matter is something of a public relations debacle for Bhutan. It exposes a fundamental flaw in the country's strategy toward achieving national happiness: How can a government propose to insure happiness for any one person, much less all of society, and how might such a thing, if achievable, ever be measured?

Bhutan's strategists understand that it's impossible to guarantee happiness for each of the kingdom's citizens or, for that matter, to measure even whether or not a single person, in fact, is happy. They do propose that it is possible to create a society that might allow a person to attain a productive and contented life, which may, in due course and with proper attitude, lead to happiness. In Bhutan's case, this strategy involves various tactics—to cultivate a sense of spiritual awareness, protect nature, enrich the cultural values of its people, and nurture the freedom of choice.

Not incidentally, these tactics align closely with Buddhist doctrine of the ruling Drukpa culture. Many of Bhutan's citizens, however, are not Buddhist (twenty-five percent are Hindus); neither are they Drukpas nor do they speak the national Dzongkha language of the Drukpas (it's spoken by only twenty-five percent of the population). These people may exist outside the reach of the government's happiness strategy. Many observers, both within and outside the country, view the hierarchy of landlords, lamas, and royalty as being indisposed to full social equality for all of Bhutan's people. It's a vexing problem: the conditions of happiness, as proposed in the Bhutanese ideal, may turn out to be only a matter of perspective, application, or, admittedly, one's position in society.

Despite these contradictions, and even according to the most ardent nay-sayers, something unique is going on in Bhutan. I thought it evident enough to warrant a visit to the land of the thunder dragon—to see for myself what life is like behind the curtains of a happy kingdom.

I landed at an airstrip near the town of Paro, alone and in a driving rain. Everyone who flies into Bhutan must land there—it's the kingdom's only international air link to the world. The fact that it was raining also was not unusual, especially for that time of year (early summer). Bhutan is one of the wettest places on Earth and receives more than five meters (sixteen feet) of rain a year, most of it during the monsoon months. That I was alone, though, was a bit out of the ordinary, at least for the customs officials whom I met at the airport, when I showed up with my backpack and without companions. It put me at odds with the other travelers in the airport, who were bundled into tight little groups led by officious-looking guides.

All foreigners who visit Bhutan, apart from diplomats and other VIP-types, must do so as members of an officially sanctioned tour. Bhutan regulates its tourists in this way to monitor their numbers and itineraries and charges each of them $250 a day to visit the kingdom. The average tour lasts ten to twelve days, so considerable revenue arrives in Bhutan along with the small raft of foreigners. The kingdom's approach to tourism, with its restrictions and high costs, is viewed by some visitors as being rather heavy-handed. The tourism planners, though, know that, while the country desires the revenue of tourism, it's not all that keen on hosting large numbers of tourists, who may disrupt local traditions and be intemperate consumers of natural resources.

Good tourism planning calculates the impacts of visitors against the fragility of a place; in the case of Bhutan, whose natural and cultural heritages are especially vulnerable, it is necessary to maintain the appropriate level of tourism. The strategy Bhutan employs to achieve this is deceptively simple. Rather than imposing a strict threshold on the number of tourists allowed to enter the kingdom, as many people believe to be the case, it simply lets the economic calculations level the playing field.

I'd heard, though, that more people are visiting Bhutan with each passing year, even with the restrictions and high costs. When I asked an official in the country's Ministry of Tourism about it, he replied that many people, indeed,

are now visiting Bhutan—maybe too many, and, as a result, they might raise the entry fee to $300 a day. Then he smiled and suggested that, perhaps, $250 a day was too cheap a price for Westerners to pay to enter a happy paradise.

I disembarked alone in Bhutan from a Druk Air flight because my travel agent in Kathmandu had created a tour that included only me. My companions appeared in name only on the requisite forms. I hadn't realized such an arrangement was possible until he made it, and even then I wasn't sure how I would be received by the immigration officials in Paro. I thought the ruse might be breaking the rules and that I'd be sent immediately back to Kathmandu on the next outbound flight. As it turned out, the airport officials couldn't have been more obliging or friendly toward me. And they thought nothing of the fact that I was a group of one person.

The customs and arrival paperwork was hastily completed, and I stepped outside the airport to discover a new, brisk, and healthy day. I had left Kathmandu in dense smog only two hours earlier; the freshness of the air I encountered outside the Paro Airport was my first clue that something different might be going on in Bhutan. It wasn't just a change in the weather but an alteration, it seemed, in the very molecular composition of the atmosphere.

The sky was filled with clouds, and the cool damp air smelled clean, damp, and pine-scented. I looked past the tiny airport to the grain fields which filled the valley and beyond to evergreen forests climbing the slopes that disappeared into the mist. I couldn't see the snow-capped mountains, but I knew they were there, too, hovering in the north, shrouded by the monsoon weather.

The last several minutes before we landed had been unnerving. As we dropped from the sky, the pilot swerved sharply into a valley so narrow as to almost clip the plane's wings. From the gray blankness inside the clouds, where the running lights on the plane's wing were the only visible things, we had plunged into a lush, terrarium-like landscape filled with greenery, dripping water, and knife edges of land. The scale of the valley seemed inappropriate to the idea of navigating a Boeing 737 aircraft. When it came time to put down, after weaving among gargantuan undulations on the valley floor, the runway literally rushed at us from a bench of gravel above a foaming river. The touchdown was nerve-wracking more for what was hidden than revealed in the landscape. It was a routine procedure for the pilots, though, and a relief

to me when the tires hit the tarmac. I joined in when the other passengers broke out in applause as the plane taxied to the terminal without incident.

When all the expense was said and done, the money I paid each day to be in Bhutan covered quite a lot. My fee included a guide, driver and jeep, lodging and meals, and a week-long trek into the Bumthang Valley with pack horses. Forty percent of the sum goes to the government as a tourism surcharge. I was assigned a new Mitsubishi jeep, comfortably outfitted for the rough roads. My lodgings were invariably clean, comfortable, and, in some cases, spectacular in their vernacular architecture and natural settings. The food was simple, fresh, and wholesome. My guide turned out to be young and enthusiastic, and he spoke excellent English. All in all, while it may not be an option to travel cheaply in Bhutan, as it is easy to arrange elsewhere in southern Asia, it's bound to be a well-managed and comfortable journey.

I was met at the airport by the Bhutanese colleagues of my travel agent in Kathmandu. Our introductions were brief. My guide's name was Chencho, and his companion, Karma, would drive the jeep. I explained to them that I wished to move about as freely as possible and to rely upon muse rather than a set itinerary to guide my travels through the kingdom. They agreed within bounds and seemed enthusiastic about such an approach. The men were accustomed to leading groups of tourists around Bhutan, and I imagined the idea of a single person with no set program of sightseeing was appealing to them.

I had brought with me to Bhutan some rare photographs made in the kingdom during the early 1960s by the geographer Paul (P. P.) Karan, a friend and close associate of mine who had first visited Bhutan upon the invitation of the king. That was long before many Westerners knew much about the kingdom and very few foreigners were allowed in it. At the time, though, Bhutan was lifting the shrouds that had veiled it from much of the world, and Paul had been asked by the Royal Government to assist in devising a national development plan. He took a lot of pictures during his peripatetic sojourn in the kingdom. My plan was to visit the locations documented in his photographs and to make repeat images of the landscape from the same perspective forty years on. I had used repeat photography elsewhere in the Himalaya, and I found it to be an enjoyable reason to move about the countryside.

Once I was settled into my lodge after the short ride from the airport, I gathered the photographs together, showed them to Chencho and Karma,

and related to them what I wanted to do while I was in Bhutan. They seized the stack of photos and pored over them, recognizing at once many of the scenes, and debates ensued between them about the exact spot from which a picture might have been made. The scenes looked different in the old photographs from what they knew of the places—the images, after all, were made before either of them was born.

With the help of the old photographs, I hoped to link visually conditions in the landscape to the King's Happiness Idea and thus to examine how the philosophical ideas behind happiness might actually translate to the lay of the land. I explained all that to my new companions. Most people visit Bhutan to learn something about its cultural life, especially that part related to Buddhism, and to view its remarkable mountain scenery. The kingdom is an up-and-coming cause celebré among travelers seeking exotic destinations. Chencho and Karma were well-acquainted with such tourists. My work with the photographs might provide them with a change of pace as well as a different sort of itinerary.

At the same time, I had a growing interest in matters of the geographical imagination, including religious attributes, and particularly how local societies might blend spiritual appraisals of nature with practical efforts toward protecting it. In the Western tradition, managing nature for the future is called conservation and is a matter of public policy and regulation. Among the Himalayan cultures, though, such protection often is an article of faith—where nature is considered sacred, it must be approached reverentially. Bhutan was a prime candidate for studying such a possibility.

Scattered across Bhutan are places that are believed to hold sacred power. The practices of tantric Buddhism, which predominate in the country, infuse such spots with religious knowledge. This may be in the form of arcane rituals, ceremonial objects, artwork, or ancient scriptures hidden in the landscape. Such repositories are known as "treasure places." It's unclear if such designations denote actual places; their existence is a matter of faith rather than cartography, and the boundaries between Cartesian reckonings and mythical space commonly are blurred in Bhutan. Nonetheless, Buddhist doctrine recognizes that the kingdom contains many such spots—it's referred to in the Tibetan literature as the "Land of Treasure Places."

Entire landscapes in Bhutan are considered to be holy because they hold a treasure place. To locate such a spot, though, requires more than a map and compass. Tradition demands that aspirants to such knowledge, people known as tertons or "treasure-seekers," must first attain the proper spiritual training and mental attitude, without which the quest would be futile. One does not "find" a treasure place so much as it is revealed, and such a revelation would come only to a person who is adequately prepared. I was not so much concerned with locating treasure places, being of a skeptical mind and admittedly ill-prepared to do so; rather, I sought to determine if the sanctity attached to them extends into the secular realm of environmental conservation. In other words, I wanted to find out if the convictions toward nature imbedded in Bhutan's Happiness Idea, which is based in Buddhist ethics, could be seen in the lay of the land. Many of the places that appeared in Karan's old photographs contain known treasure spots, and I wished to see how the land had fared after almost half a century of human inhabitation.

In the end, I thought my photographic inquiry might illuminate not only the practical implementation of Bhutan's happiness policy, but also its connection to the deeper spiritual currents in people's lives. I wasn't seeking to vindicate any of this but simply to document whether or not it might be seen in the ways in which ordinary people manage their world as they go about their daily affairs. In such a way, I thought I might be able to connect the vernacular landscape in Bhutan with the king's idea about happiness and both to the prosaic matters of living deeply in a place.

The drive from the airport to my lodge took me up a pine bluff overlooking the valley. From the veranda of my quarters, I enjoyed sweeping views across the valley to the town of Paro, which appeared as a line of single-story shops and homes strung along a road paralleling the river and beyond to the outlying farms and forested ridges above the valley. The houses I observed from my veranda were of uniform design, pleasantly arranged, and of local architectural style; according to the Happiness-based national planning codes, all new structures in Bhutan must follow the traditional designs, so it is difficult at a distance to distinguish between old and new. The homes were made of rough-sawn timber and stone, with overhanging roofs, and appeared solid and long-standing. They occupied the hillsides above the valley, leaving the

valley floor to agriculture. The summer wheat and barley crops filled the cultivated fields with alternating waves of greenery so that the valley had a checkerboard look to it.

The most conspicuous feature in the landscape was an ancient and imposing, fortress-style structure (called a dzong) built to house both Buddhist clergy and public officials. The dzong is one of Bhutan's unique architectural gifts to the world. Most of the dzongs date back many centuries and evoke an antique, medieval-era bearing. They are one of Asia's most beautiful structural forms, with inwardly inclined walls several stories high, pagoda roofs, and intricate woodwork. The Paro Dzong I viewed from my perch was built in C.E. (Current Era) 1644 and is one of the most magnificent in Bhutan. Its proper name is Rinchen Pung Dzong, which means "fortress on a heap of jewels."

Attached to the dzong was a circular watchtower that had served in the past to give notice of attack to those inside the dzong. It now serves as a museum. The Paro Dzong had successfully repelled invaders from Tibet many times, and the Western explorers who first chanced upon it in the early twentieth century wrote that the watchtower still favored the old catapults that once launched huge stones at would-be attackers. The tapered whitewashed walls of the tower were punctuated by narrow slits, where archers had kept watch over the valley. A suspension bridge festooned with prayer flags spanned the river to provide access to the dzong for people living on the far side of the valley.

There was still time that day to visit the dzong, my guides had left me to my own devices, and so I walked across the valley to the structure and entered another world. Inside, monks in hooded saffron robes casually mingled with officious-looking government clerks. Huge slabs of stone fashioned the floors of open courtyards, which, in turn, were lined by rows of meditation cells and deep-set altars. Incense burned continuously, blackening the walls with sandalwood and forest-herb smoke. The musky scent wafted across the compound. The courtyard walls were painted in colorful murals of writhing demons and beatific saints, all overlooked by a multi-level maze of balconies, passageways, and balustrades. Potted geraniums and marigolds brightened the scene. It looked ancient inside the dzong—timeless, in fact, if one ignored the few visible accoutrements of modern life: dangling electrical cords, a flashing-green computer monitor, and other technological odds-and-ends. I lingered until dusk and then returned across the valley to my lodge.

Several of Karan's photographs were made in the Paro Valley. I made plans with Chencho and Karma to visit some of the spots on the following day. They joined me early in the morning for tea, and together we examined the photographs, this time using a detailed map to check the most likely locations. Chencho had mentioned the photographs to members of his family, who wanted to look at them, so we drove over to his house first. I sat there with his uncles on hand-knotted rugs and drank more tea while they examined the prints. Some of the elderly men recognized in the early scenes the places of their memories. They offered suggestions about the vantage points from which a photograph might have been made. I marked the spots on my map. When it seemed we had exhausted the possibilities, Chencho said it was time to go, the day was getting on, and we took leave of his family.

The road past Chencho's house wound slowly up the western side of the valley toward the Drukgyel Dzong, where it came to an abrupt end. Beyond that point a walking trail leads to Tibet via the southern slopes of Jhomolhari, a 7,314-meter (23,996-foot) peak that towers above the valley like a huge, spectral monolith. The Drukgyel juncture had been a bustling way-station along the trade route to Tibet until 1951, when an overturned butter lamp burned down the dzong. Only the walls remained standing, and the monastery, now in ruins, appears at the head of the valley in ghostly silhouette against the looming white face of Jhomolhari. I made a few photographs at the spot.

After visiting Drukgyel, we turned into a side valley that led to the Taktsang Monastery. The temple is perched spectacularly against a cliff face 700 meters (2,300 feet) above the valley and is accessible by a narrow trail cut into the rock. It's one of the most revered places in the Himalaya. The name means "tiger's nest" and refers to the belief that Guru Rinpoche, a venerated saint who had spread Buddhism throughout the Himalaya during the eighth century, had flown to the monastery on the back of a tiger. The site contains thirteen holy places, but the most important one is a cave at the back of the temple, where Guru Rinpoche had meditated for several months before embarking on his quest to convert the Paro Valley to Buddhism. A tiny entrance to the cave is guarded by his image in the terrifying form of the demonic Dorje Droloe, and inside the enclosure are secret paintings that illustrate the arcane teachings of Guru Rinpoche's "magic dagger" treatise.

It is impossible now to enter this innermost sanctum of the Taktsang Monastery, but the complex itself is wide open to view, and the setting offers a stunning example of how matters of faith may interpret the natural world. Isolated and difficult to reach, the hermitage is poised at the very threshold of land and sky, providing a retreat from the one and a bridge to the other. Its auspicious placement and the fact that many famous Buddhist saints and yogis meditated in this spot—including Milarepa (C.E. 1040–1123), Machig Labdoenma (C.E. 1055–1145), and Guru Rinpoche—make it an intensely spiritual place for the Bhutanese people.

Chencho and I climbed the cliff to gain a closer look at the temple. Our view from beneath the protective gaze of a ferocious-looking gargoyle took in more than the tiger's nest: columns of shimmering rock, wind-blown pines, and wispy clouds animated the phantasmagoric scene. The temple itself looked like it had been chiseled out of the cliff face. Peering down the valley, we observed topographic alignments that mirrored those in some of my photographs, so we scampered down the cliff to the jeep while Karma drove to a nearby overlook, which seemed to offer the best angle on the landscape. We stopped there and left the vehicle to hunker over the pictures. Engrossed with our photographs, we didn't notice the farmer who'd made his way up the slope from a field, where he'd been working, until the man sidled right alongside us. He asked Karma what we were doing and pointed to the stack of photographs.

We showed the farmer the picture we'd been examining and explained that it was made almost half a century ago and that we hoped to locate the exact spot from which the image had been taken. The man held the print close up and slowly examined its features, tracing his dirt-stained finger along the line of buildings, trails, and field boundaries. Then he looked up, smiled broadly, and said he knew exactly where it was made. He explained that he'd lived his entire life in the valley and knew it well, offering that things hadn't changed that much since the time of the photograph—just a few additional homes, some electricity lines, and the road that had been recently paved. He'd take us to the spot.

We hopped into the jeep and, with the farmer directing us, drove down the road to where the geometry of the terrain matched that in the photograph. I set up my camera, made some images, and then sat down to talk with the farmer.

He had a lot to say about the place. I listened to his discourse on tilling the land amid the fickle moods of the monsoon, on the price of yaks, and about the meddling presence of local deities. He spoke in concrete terms, using the language of ordinary people. The philosophical terms about happiness, articulated in the government polices, hadn't yet entered his vocabulary. Still, his references suggested a theme that resonated with the king's happiness proclamation; the farmer told us he couldn't imagine a better place to live. When I asked him why he thought that, the man replied: because the land thereabouts was blessed. Beyond that, he said, his life was a lot of hard work.

I noted in the photograph how few additions to the landscape were evident over time. The new buildings had the same basic design as the old structures, so they weren't that obtrusive in the modern scene. The area of farmland was essentially the same—still limited to the valley floor and free of the societal encroachments I found in other Himalayan valleys. The hillsides looked to be in even better shape than they had in the past, judging from the forest cover and large trees. I asked the man about these things.

As a farmer, he understood that the best land for crops was located on the valley floor, and so, in his opinion, it was entirely appropriate to save it for that purpose. He remarked that the government no longer allows the villagers to graze their animals freely on the wooded slopes of the valley but rather regulates fodder collection in the forests according to seasonal schedules. He added that, several years ago, public officials encouraged villagers to plant trees on private lands to help them secure their own sources of fodder and firewood. This appeared to be working. Meanwhile, new forests were established by the government on the common lands. These changes showed up in the photographs, which visibly demonstrated how time and the new policies might actually improve the conditions of the land.

We left the farmer to his work and continued further along the main road, detouring in places up side tracks to scout spots thought to be likely candidates for my photographic project. Most often these didn't lead to a site, but they provided new revelations about Bhutan. On occasions when Chencho and I left Karma with the jeep and proceeded on foot, we often crossed streams on suspension bridges. Some of these bridges were made of heavy iron chains. The chain bridges in Bhutan are regarded to be the work of a sin-

gle person—the Tibetan saint Thangtong Gyalpo, known as Lama Chazampa (the Iron Bridge Lama). He's believed to have constructed eight such bridges in the Paro Valley and altogether 108 iron chain bridges in Bhutan and Tibet. Lama Chazampa also was an important terton and had acquired the title of the "Great Magician."

Back in the jeep after one such excursion, I asked the guys what they thought about this treasure business. Chencho and Karma were worldly young men. Bhutanese custom requires that, in public, all men wear the traditional wrap-around garb, called a *gho*, but they quickly shed their outfits once we entered the countryside, revealing the jeans and T-shirts they wore beneath and donning knock-off designer jackets, sunglasses, and NFL baseball caps. The cassette player in the jeep played Western electronic music mixed with Hindi cinema tracks. They drank beer imported from India and emailed friends around the world. I was curious to know how the mysticism and magic that pervades the kingdom sat with them.

Chencho replied that it all was true—that treasure places exist in Bhutan, and that, moreover, if we played our cards right, we might just stumble upon one. Karma agreed with him. They both insisted that the mythology associated with places in Bhutan is actual history, that saints really do populate the landscape, and that the country as a result is, in its entirety, a holy realm. They were quite adamant about it, and I determined to keep an open mind about the matter.

During the next few days, we explored the Paro Valley, traveling by jeep on dirt roads and walking up steep trails to ridges and into gorges. During our perambulations, we came across numerous sacred markers in the landscape—pyramid-shaped chortens that contain relics of saints, painted cliffs, caves, temples, and carved stone walls. Wherever a spot matched a photograph, we stopped so I could make new pictures. We located people nearby who could explain to us the nature of the changes we encountered in the scene. It was easy to elicit such help. A lot of folks were interested in Karan's old photographs, and it became something of a game for them to lead us to the spot where an image was thought to have been made. When we stopped to compare a scene with the contents of a photo, lively discussions ensued amid a gathering crowd. For many people, the time line of photographs contained their lives and thus held great interest for them. Others registered surprise

that so little had apparently changed between 1964, when Karan made his pictures, and the present-day.

The absence of major shifts in Bhutan's landscape, at least from a photographic viewpoint, runs counter to the large-scale transformations I've observed elsewhere in the Himalaya. It's as if, during the past thirty-five years, I've been witness to a great disassembling of life in the Himalaya, with cultures losing much of their historical bearing and with natural heritages made more vulnerable by the inroads of the world economy. These events are borne out in the look of the land, which bears testimony to the broader shifts in mountain society. Such a transition has been a focus of my studies in the Himalaya, and Bhutan provided me with an alternative perspective on it.

It's not that Bhutan entirely sidesteps such change, as if it were some kind of wunderkind, but rather it moves more slowly along these paths. To some degree, it's a matter of geography: Bhutan is a sparsely populated country, rugged, and remote—more so than many other places in the Himalaya—and it stands to reason that, under such conditions, the pace of change may be slow. It also has historically kept much of the world away, and, as a result, modernity has come more slowly and cautiously to Bhutan. That now is changing, however, and the flux, ironically enshrined in the Buddhist hallmark of impermanence, is quickening, which keeps Bhutan on its toes.

The King's Happiness Idea intends to put a check on the more invasive aspects of modernity. This intention was captured in my photographs, which showed places less imperiled by the changes in society than those I have noted elsewhere in the Himalaya. In many cases, my photographs registered actual improvements in the landscape. Of course, it's easy to imagine that the viewfinder of my camera pointed only to places that were still in good shape, such is the editing possibility of one's vision and the technology. But I thought it unlikely because most of the vantages I photographed were along roadways or adjoining landscapes. Such places are the most likely candidates for pernicious development simply because they are most accessible. I thought that, if they displayed a healthy character in my photographs, then the more remote places in the kingdom might be in even better shape.

To a certain extent that is true. Almost three-quarters of Bhutan is covered in native forest. The largest tracts of it lie beyond the reach of the towns,

roads, or bridges. The forests contain an astonishing richness of life: more than 5,000 types of plants inhabit the wilderness, including fifty species of rhododendron, 600 orchids, 165 mammals, and about 800 birds. Some of the animals are among the most endangered on the planet: for example, the snow leopard (*Uncia uncia*) and red panda (*Ailurus fulgens*) in the high mountains and the golden langur (*Trachypithecus geei*) and Bengal tiger (*Panthera tigris*) in the lowland jungles. The fact that such animals exist at all in Bhutan is testimony to the large tracts of land it preserves in native habitat.

Such diversity of life is enabled by the kingdom's topography and climate. Bhutan is bounded by the Plateau of Tibet in the north and Indian lowlands in other directions, and it contains elevations ranging from 100 meters (330 feet) above sea level on the Duar Plain of India to 7,554-meter (14,783-foot) Gangkhar Puensum Peak along Bhutan's frontier with Tibet. A spine of highlands spans the country from west to east, and the land cascades southward in a series of ridges and valleys. The varied topography produces temperature fluctuations beyond the broader shifts of the season. Meanwhile, the summer monsoon dumps an enormous amount of rain of Bhutan, which supports the kingdom's unusual gathering of plants and animals.

The natural heritage of Bhutan loomed everywhere in my camera's viewfinder, sneaking into the frame of a picture at its corners or establishing itself as the centerpiece of an image. The sheer beauty of the land often was overwhelming. My primary concern, though, was with how human society alters the conditions of nature, and I continued to focus my photography on that. Rather quickly, I amassed a large selection of landscape images, many of which had direct comparison to Karan's 1964 pictures. With rare exceptions, the comparisons showed a favorable outcome: the forests had gained territory, farmland remained intact, and, in most places, the new structures were limited in scale and obtrusiveness.

Absent from most of the photographs were the images of modern society commonly encountered in the Himalaya: road alignments causing erosion, sprawling settlements, advertising billboards, and power lines crisscrossing valleys and snaking up ridgelines. Bhutan has tried to minimize these encroachments, deciding, in once instance, to bury its electrical lines. In the Phobjikha Valley, where the rare and lovely black-necked crane (*Grus nigricollis*)

winters over, all overhead power lines are banned and the homes are solar-powered—in order not to disturb the birds' flight paths nor challenge their migrations with altered magnetic fields.

During the course of my jeep sojourns in Bhutan, I often traveled on tracks best suited for pedestrians, but still I wanted to walk through the countryside away from roads. Chencho arranged for a horse trek into the Bumtang Valley, and Karma drove us to the spot where we met our horseman. I had selected the Bumtang Valley because of its photographic possibilities and because it was famous in Bhutan for its treasure places. The valley was known to contain many ancient monasteries and sacred sites, and legend filled it with a host of important religious figures, including Guru Padmasambhava, who allegedly visited and meditated in the valley and left behind many sacred teachings. Of all places in Bhutan considered to be a sanctified realm, the Bumtang Valley stands out, and I thought it might display its ethereal quality in the way its inhabitants live. When Karma left us at the end of the road, I imagined our trek into the valley as a sort of pilgrimage into the mind of a society.

The horseman was waiting at the trailhead when we arrived. He packed the ponies beneath a carved Buddha overlooking a stream. The trail began wide and gradual, so the walking was pleasant. Less than an hour into our trek, at the ford of a stream, we met the princess of Bhutan. She had been visiting the renowned Swan Temple, located a few hours further up the trail, in a part of the valley known as the Land of Swan, and she was heading back to the trailhead, where her driver and jeep awaited her return. We exchanged a few words at the crossing—she was curious about my adventures—and then wished one another well as we wrung stream-water from our shoes and parted ways. I thought it an auspicious beginning to our trek—meeting a princess in the Land of Swan—and Chencho agreed with me.

A few hours later we passed through a cluster of rustic houses to a Tibetan-style chorten surrounded by a grassy encampment and rows of prayer flags. This was the Swan Temple. We set camp nearby and ate a meal of buckwheat pancakes flavored with a mushroom-pepper-cheese sauce. It is the local delicacy. Some village women came to greet us and to sell me some strips of woven cloth called *yathra*. The fabric was nice, but I had no need of it. I was interested, though, in the basket that contained them—my wife is a basket-maker in Kentucky. It was a splendid example of local handiwork, and

I sought to purchase it as a gift. After some bargaining, I walked away with the basket, which the horsemen later used to store ropes and extras stays for the tents. The women then put their handiwork in a cloth sack and disappeared. It was beginning to rain by this time, and we all fled into our tents. The sounds of the rushing river were dampened by the mist that had settled onto the valley like a wet blanket, and it quickly grew dark.

I awoke early the next morning anticipating a long climb to the pass at Phephe La. It was still raining when we broke camp. The trail narrowed a short distance beyond the temple, and we entered a dense forest. For the remainder of the day we slogged up a muddy incline through cold and dripping trees. Groves of bamboo lined the path. We crossed streams on slippery logs and stones and fought our way through tangles of rhododendron. When we finally reached the top of the pass, the mist was so thick we could barely see a meter (a yard) ahead. Chencho said that, on a clear day, from that spot a beautiful snowy ridge was visible across the yak pastures, but the view that day was limited by the fog and low-lying clouds to a dull and wet emptiness. We didn't linger atop the pass but dropped straight away into the gorges of the Tang Valley, where we set camp.

Few people live in the Tang Valley—it's too high for farming and lacks pasture. Herders, though, frequently pass through the area on their seasonal migrations, their livestock trampling and browsing a crisscross of trails through the wilderness. The main trail was well-marked with human imprints: stone cairns, cliff paintings, carved rock walls, prayer wheels straddling streams, and an occasional small temple or monastery. The religious markers lent a sense of sanctity to the place and showed an attention to the land beyond the practical needs of the farmers and herders. In many places, mossy shrines were perched above difficult stream crossings as if a benevolent wayside guardian. The few homes we encountered seemed prosperous enough with well-made buildings and productive fields. Prayer flags fluttered brightly above them.

The Tang Valley is renowned among practitioners of tantric Buddhism as one of the Himalaya's great sacred places—the holiest place in the Bumthang region. Bhutan's most famous terton, Pema Lingpa (C.E. 1450–1521), was an inheritor of the Nyingma school of Tibetan Buddhism and a native of the hamlet of Drangchel in the Tang Valley. Legend associates Pema Lingpa with all manner of religious discoveries, beginning at the age of

twenty-five when he dreamed up a map to Tang's most sacred treasures. He went with his brothers to a point in his dream-map, where the Tang River had broadened into a lake, plunged into the frigid water, and retrieved a chest of rare meditation scriptures. His other discoveries—statues, scrolls, and sacred relics—brought fame to Pema Lingpa and the valley. The ritual objects he obtained supported his ecumenical teachings, for which he became famous, and they were distributed among the monasteries of the valley, making them important destinations for pilgrims even today.

My own trek through the Tang Valley uncovered no such treasure. The relics and esoteric knowledge eluded me as I cast my geographical gaze on the landscape. Still, I glimpsed a place that showed equanimity and mindfulness. It played out in the tidy little farms and well-tended fields. When we crossed the high passes and descended into uninhibited valleys, I discovered verdant worlds of azaleas, rhododendrons, and orchids. I thought that, perhaps, here was a place that held the possibility, at least, of the kingdom's moral and practical pursuit of happiness.

Admittedly, I was not troubled to equate the Tang Valley or Bhutan generally with spiritual treasures or a societal idyll. I'm sure both or neither could be found there—a result of one's predilections. That it might hold the promise of happiness, where a person could find the necessary ingredients for a satisfying life, is also largely a matter of point of view. That is for the Bhutanese to determine. The kingdom struggles with the challenges of most modern societies—making sense out of the past so it may provide counsel for the future—and the degree to which it succeeds through the application of its concept of happiness is certainly debatable. At the least, for me, it offered the notion that such a quest is legitimate.

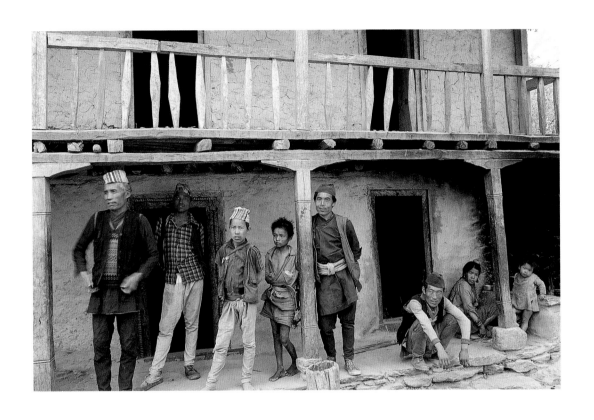

33 A trading post in the Rukum District, north of Phalabang, Nepal, 1985.

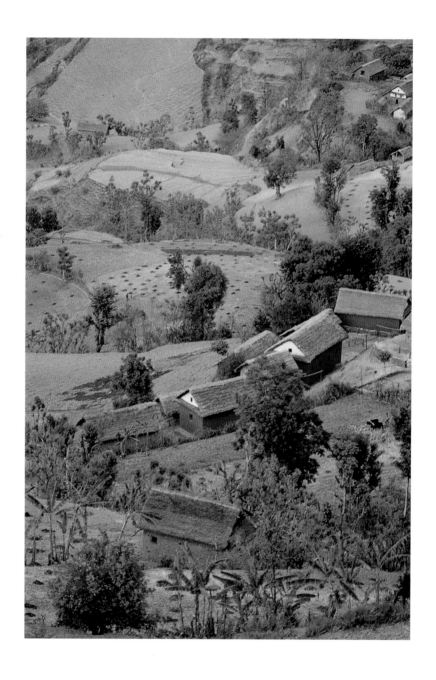

34 *Farmland in Phalabang, in late spring before the onset*
of the summer monsoon, Nepal, 1985.

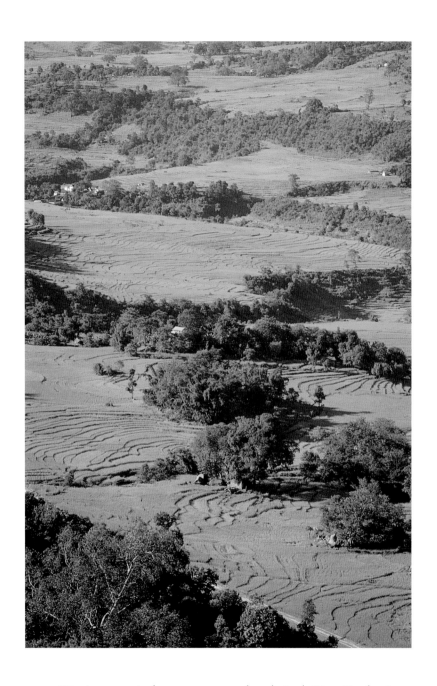

35 *Wet rice terraces in the monsoon season, along the Sarda River, Nepal, 1985.*

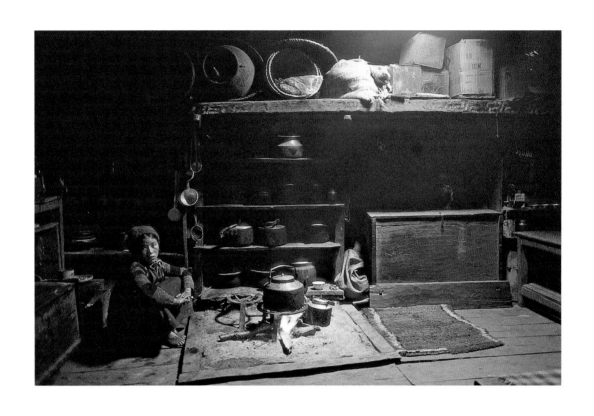

*36 Village tea houses provide food and lodging to travelers
on the mountain trails of Nepal, 1988.*

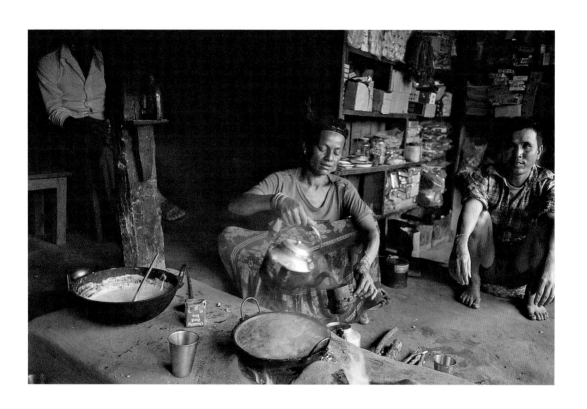

37 A tea house in Phalabang, Nepal, 1985.

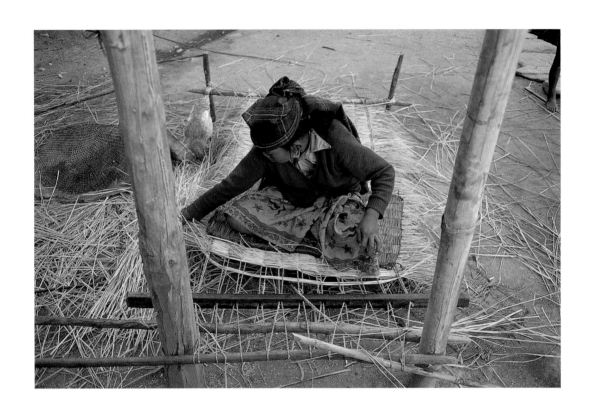

38 *Weaving a household floor mat (called a ghundri), Nepal, 1987.*

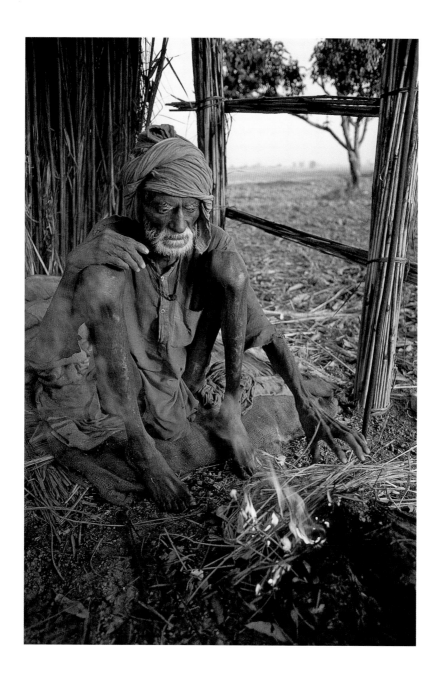

39 A landless farmer in the Dang Valley, Nepal, 1985.

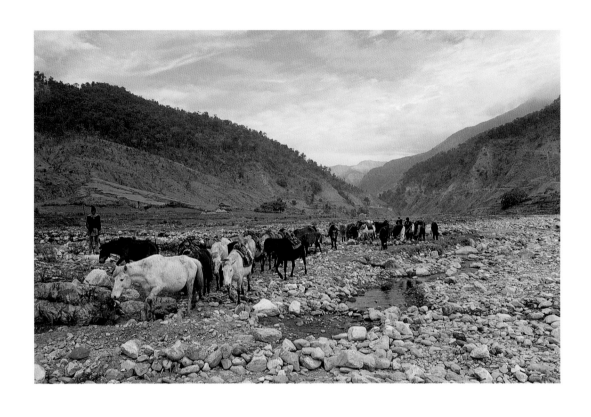

40 *Trade caravans regularly pass through Phalabang on the trip to Dolpo, Nepal, 1985.*

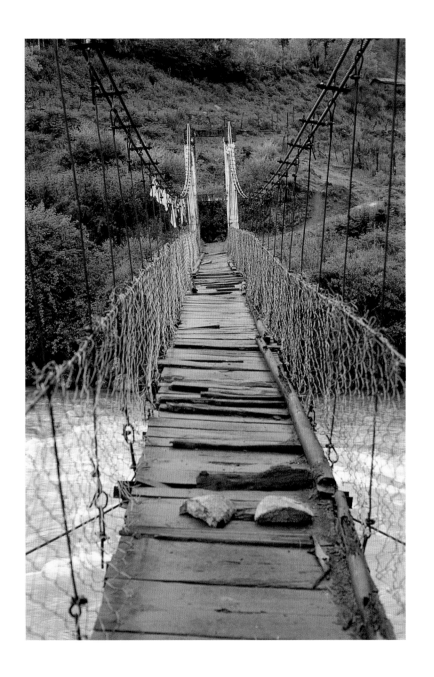

41 *A typical suspension bridge across a mountain stream in Bhutan, 2004.*

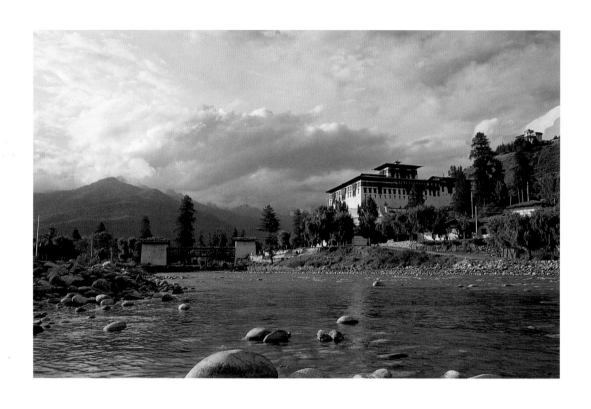

42　*Religious and secular affairs comingle in the spectacular Paro Dzong, Bhutan, 2004.*

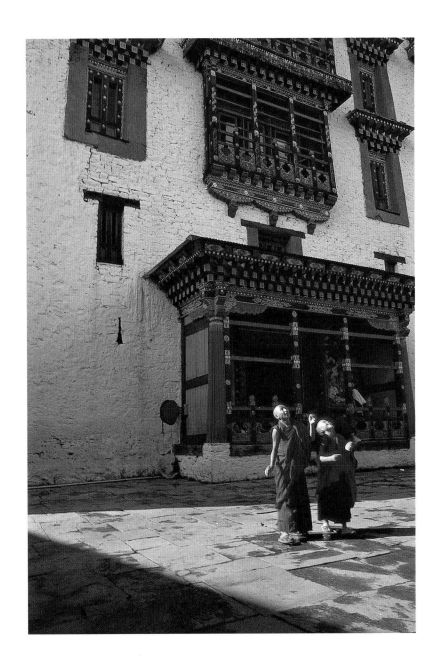

43 *The interior courtyard of the Paro Dzong, Bhutan, 2004.*

44 The forests of Bhutan, renowned for biodiversity, contain more than sixty species
of rhododendron, a shrub or small tree of the heath family, 2004.

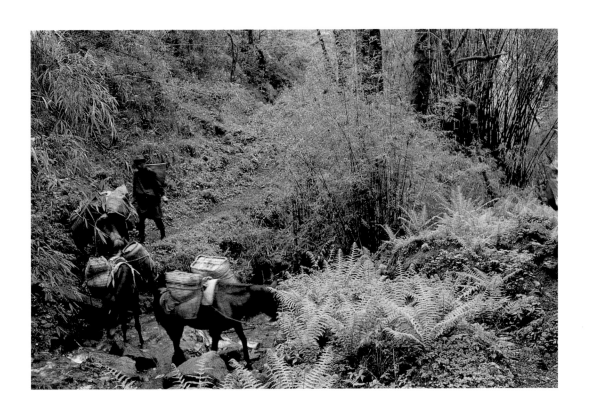

45 *Difficult trails connect the isolated villages in the Bumthang region of Bhutan, 2004.*

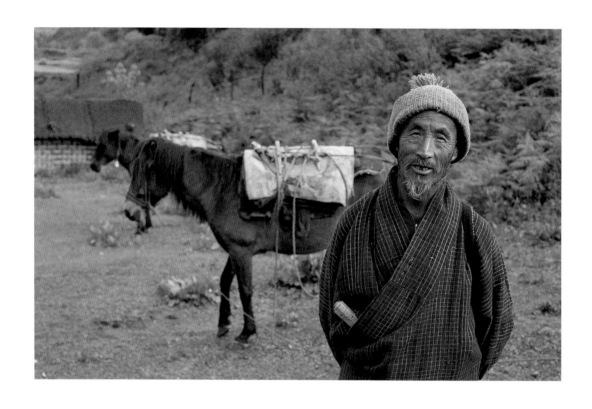

46 *A Drukpa herder in the Bumthang valley, Bhutan, 2004.*

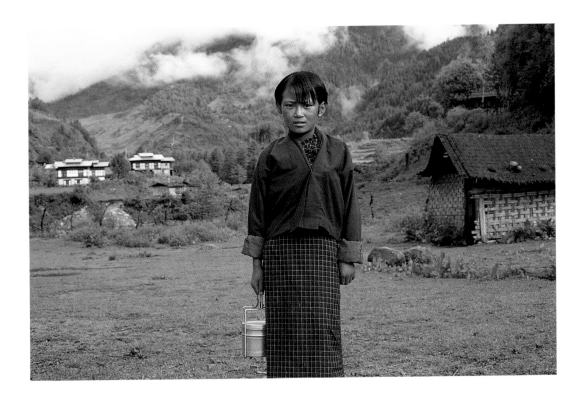

47 *A village girl on her way to school in the Tang Valley, Bhutan, 2004.*

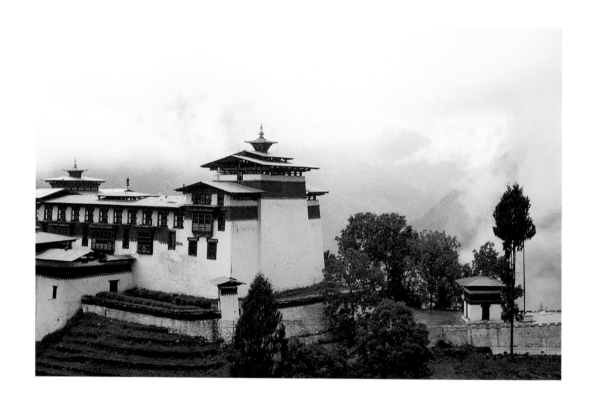

48 *The Trongsa Dzong, one of the kingdom's largest structures,*
is in the central part of Bhutan, 2004.

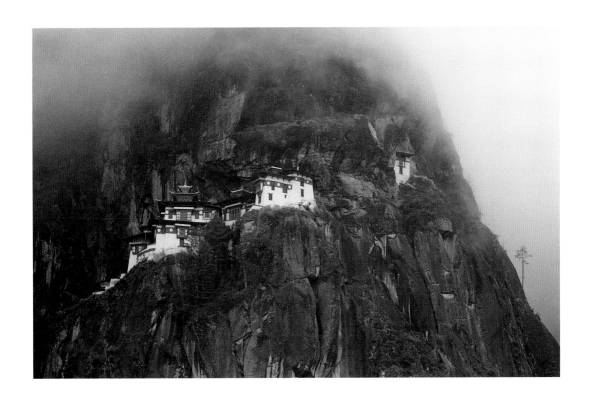

49 *The Takstang Monastery (also called Tiger's Nest) is situated 700 meters (2,297 feet) above the Paro Valley, Bhutan, 2004.*

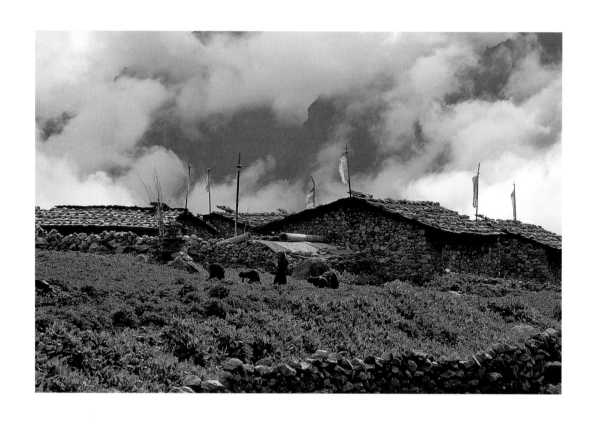

*50 Summer monsoon clouds reach the stone and shingle homes
of a high-altitude village in Nepal, 1988.*

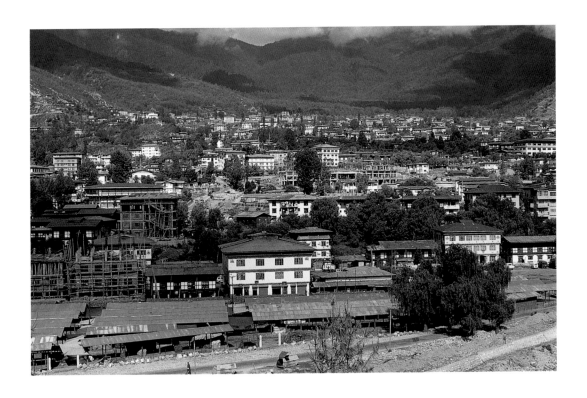

51 *The unobtrusive skyline of Thimphu, Bhutan's capital city, shows the use of vernacular architecture and the strict restrictions placed on the heights of buildings, Bhutan, 2004.*

52 *Gathering sufficient wood for the winter months is a necessity
for all areas of the high Himalaya in Nepal, 1990.*

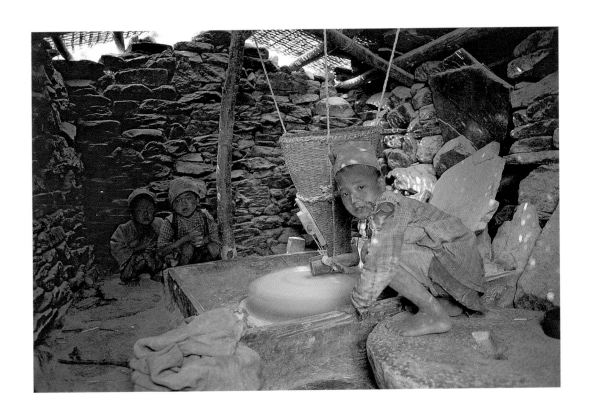

53 *Stream-power is used throughout the Himalaya to get work done,*
in this case grinding flour in a village millhouse in Nepal, 1985.

54 A Nepalese highland farmer with a basket of cold-weather spinach, 1988.

55 *A hill tribe woman of Gurung ancestry, Nepal, 1985.*

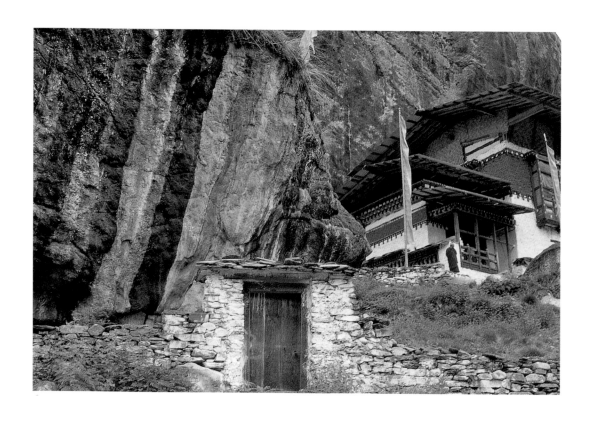

56 *Rimochen Monastery is a famous place for meditation in the* bey-yul *(hidden valley) of Tang, Bhutan, 2004.*

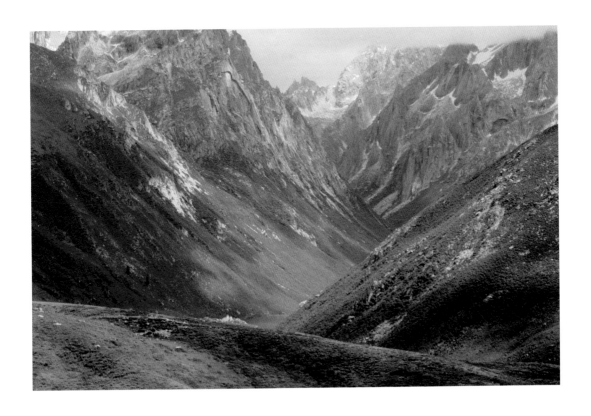

57 *The rugged highlands of Kham in eastern Tibet, China, 2006.*

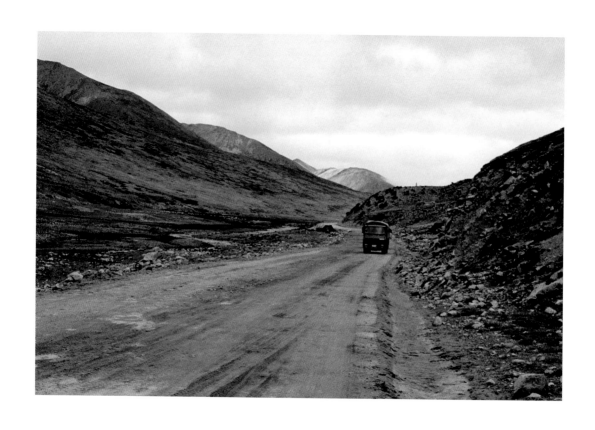

58 A Chinese Army truck patrols a remote sector of Tibet near Chamdo, China, 2006.

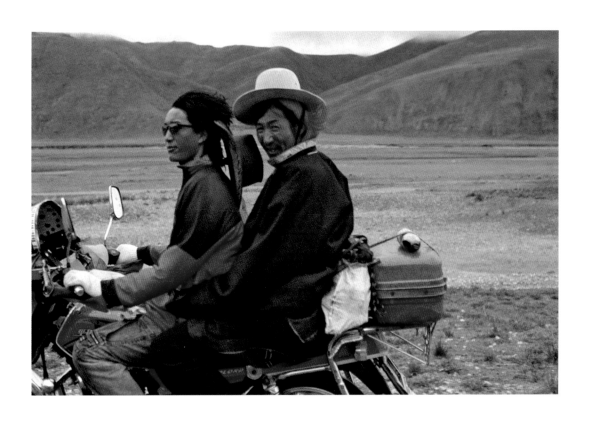

59 *Motorbikes are preferred over horses among increasing numbers*
of nomads living on the Tibet Plateau, China, 2006.

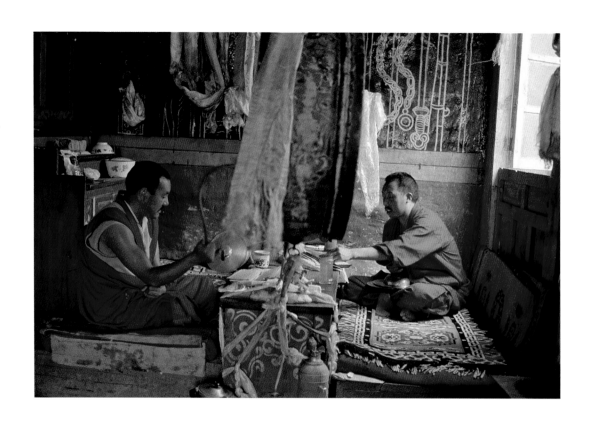

60 *Monks at prayer (puja) in a Tibetan monastery, China, 2006.*

61 *Making a traditional wood-block print in Dege, China, 2006.*

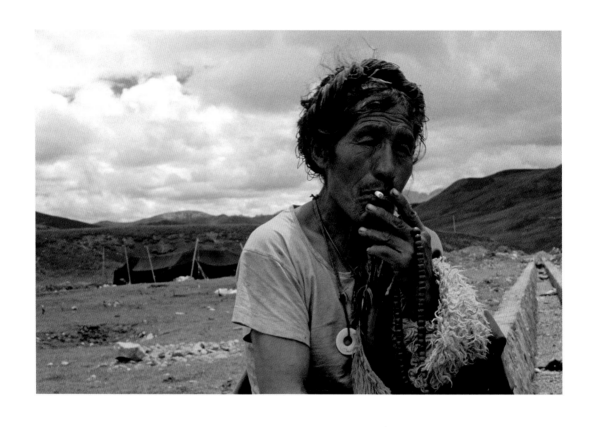

62 *A pilgrim near Mount Genyan in Kham, China, 2006.*

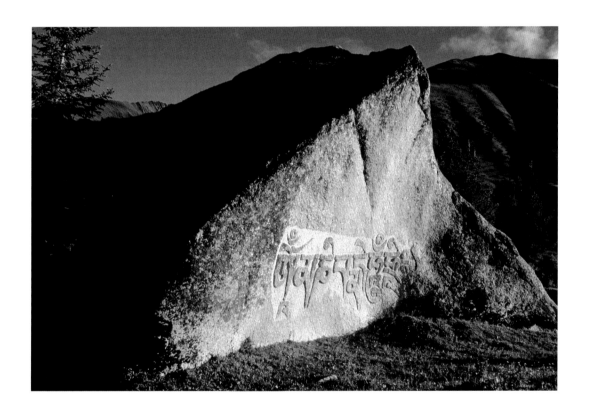

*63 A carved scriptural stone (a mani stone) overlooking Yilhun Lhatso,
a sacred lake in the Dzogchen Valley of Tibet, China, 2006.*

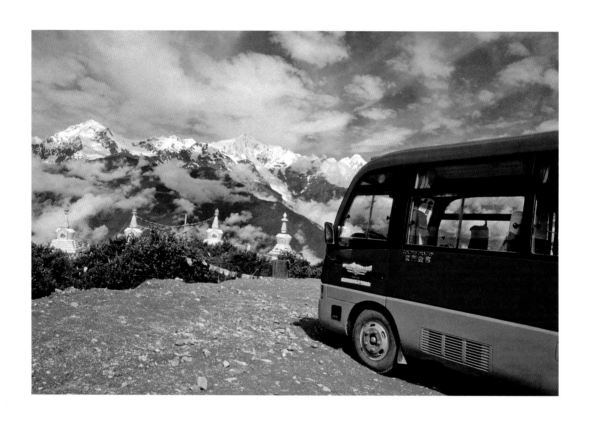

64 *A tour bus at the Kawa Karpa overlook in Dechen, China, 2006.*

A MAP OF SHANGRI LA

(Yunnan and Tibet: 2006)

AN IMMENSE PLATEAU covered in wildflowers and filled with shaggy-headed yak extended to the horizon. The animals grazed on the plain with bowed heads, moving placidly in the grass, their stillness and shape suggesting large, black boulders. The sky was heavy with cloud and hung low to the ground, pierced in the distance by shafts of sunlight that illuminated a cobalt lake and range of snowy mountains. The sweep of land in front of me was like no other place I'd been in the Himalaya. The clarity of the high altitude air produced a highly resolved effect, and yet there were few enough obstructions that, overall, the place was Zen-like in its seemingly empty and limitless space.

This part of Tibet is known as Kham. It's located on the eastern edge of the Tibetan Plateau, within reach of the Asian monsoon. Unlike most of the interior of Tibet, which is bone-dry and devoid of plants, Kham is green much of the year, with grassy plains and large swathes of forest in the valleys. The summer rains had already settled onto the plateau when I arrived in June, turning it into a huge, emerald disc. Scattered across the scene were encampments of nomadic herders. Their dark tents—made of rough, hand-spun, yak-hair—popped out from the green plateau like the famous matsutake mushrooms that grow wild in the region.

The nomads' tents were fastened with long stays anchored firmly to the ground to hold them upright against the strong winds that buffet the plateau. Each tent held a single family. They were placed individually in the countryside, rather than in convivial clusters—a sign of the practical matters of

nomadic survival, which requires access to sufficient pasture land. It was quiet around the encampments. The household belongings were stored inside, guarded by huge mastiffs, and the inhabitants were off tending the livestock that dotted the hillsides or gathered in small herds along the stream banks. Horses grazed in the nearby fields.

Kham lies north of the great gorges of the eastern Himalaya, where the Salween, Mekong, and Yangtze rivers thunder down from the mountains to water much of Asia, and it occupies a solid chunk of tableland adjoining the Chinese provinces of Sichuan and Yunnan. It's known among the Tibetans as Bodh Po (the "high land") and is filled with stunning monuments: temples and huge monasteries, trading posts, and ceremonial grounds, where nomads congregate to dance, eat, and drink amid bright clusters of diamond-patterned tents.

The people who inhabit this place—the Khampa ("people of Kham")—move seasonally with their animals amid some of the most rugged terrain in the world, drink sour mare's milk, and subsist on roasted barley flour, yak meat, and salty butter tea. They are famous horsemen. Their clothing is crafted from wool, animal hides, and handspun fabric or, on special occasions, colorful Chinese silk. The women wear heavy medallions of silver-studded jewelry adorned with coral and turquoise, and the men wear their hair long and stylishly braided under felt or leather cowboy hats. The Khampa adorn their horses with an equal flourish, with beautifully woven saddle blankets, bells, and hand-wrought leather-and-silver saddles. Traveling among the Kham nomads, I felt in the midst of a proud, rugged, and elegiac celebration of life.

Throughout much of its history, Kham remained isolated, in part because of its difficult terrain and harsh climate, but also because the Khampa had fierce reputations as bandits and murderers. They plundered the Chinese caravans that passed through Kham en route to Lhasa. The intrepid French explorer Alexandra David-Neel (1868–1969), who had spent thirteen years in eastern Tibet during the early 1900s and came to know the Khampa better than any other Westerner, referred to them as "Gentlemen Brigands." She thought them chivalrous as much as larcenous.

Kham's isolation ended and the region suffered when the Chinese invaded and occupied it, beginning in 1950. By then China had determined

that it owned Tibet and initiated a military campaign to secure it. More suffering was wrought during the 1970s and the Cultural Revolution, when all civility in China was crushed under the repressive weight of Maoist dogma. The first military excursions into Tibet met fierce resistance in Kham, particularly at Chamdo on the banks of the Mekong River, not far from where I camped, but with superior numbers and technology the Chinese army quickly overpowered the guerilla fighters. In scorched-earth fashion, the Han soldiers marched across the open terrain toward Lhasa, leaving Kham in ruins: demolished monasteries, massacred monks, and people with a shattered culture.

Kham was locked down with the rest of Tibet during much of the twentieth century. Military campaigns secured the countryside amid terror and destruction. Few people were allowed access to the plateau, and foreign journalists were forbidden altogether from entering the region. Meanwhile, the Chinese media reported that the occupation was bringing prosperity to Tibet by eliminating the vestiges of its feudal past: the monastic lands were spit up into ill-suited communes, monks were removed from positions of power or killed, and karaoke bars and brothels opened to serve the Han army men. The Tibetans, who had no voice in the matter, were held witness to this determined and often horrific transmogrification of time and space. The cultural demolitions that occurred during the invasions are evident still in Kham: the mud ruins that straddle the ridges look like ancient eroded battlements but they are less than fifty years old, and there is the sense of outrage and injustice felt by many of its inhabitants.

The isolation of Tibet began to lift in the mid-1980s, when certain sectors of it were opened to foreign tourists. The Beijing authorities loosened their grip on Tibet, when they realized that its appeal among Westerners would bring foreign revenue to the national economy. By this time people in Europe and North America had learned of the plight of Tibet and the violation of human rights there. Not a few persons, including many celebrities, became students of its religious traditions. The Tibet House was established in New York City in 1987 by Columbia University professor Robert Thurman (father of actress Uma Thurman), Richard Gere, and musician Philip Glass, among others, to support the cause of Tibet, its people, and their form of Buddhism. The Dalai Lama was awarded the Nobel Peace Prize in 1989. Centers of Tibetan Buddhism sprouted up all over Europe and North Amer-

ica. A gradual awakening in the West to the spiritual promise of Tibet eventually led to a resolution by Westerners to travel there.

The first wave of tourists concentrated on Lhasa, which was considered to be the geographical heart of Tibet. With its many important religious and historical monuments, Lhasa constituted the "essential" Tibet for those interested in its political and religious history. Travelers venturing away from Lhasa early on had to contend with surly frontier officials, an impenetrable bureaucracy, and deportation. The travel restrictions remained in place until 2002, when the Chinese authorities opened eastern Tibet to foreign travelers, began building tourism infrastructures there, and advertised the region to the world as the fabled land of Shangri La.

British author James Hilton had coined the phrase "Shangri La" in his novel, *Lost Horizon* (1933), to describe a magical place, where people lived amiably amid spectacular natural beauty—a seeming paradise on Earth. The phrase caught on. Hilton's Shangri La, though, was meant to be lyrical, whereas the Chinese are working hard to engineer it into a real place: building roads and bridges, towns and lodges, signboards and amusements intended for the large numbers of tourists predicted to visit the region in forthcoming years. The rugged terrain makes the job difficult, even for the Chinese, who have shown they can build massive things in some of the most unlikely places. The biggest hurdle, though, is a marketing challenge: people must believe in Shangri La before they can be persuaded to visit it.

The creation of Shangri La as an actual place on Earth is an intriguing notion, because, of course, it never was meant to be such a thing. James Hilton lived in China and had spent time in the Himalaya, and there is reason to believe he based his fictive place on the ancient Tibetan concept of Shambala, which denotes a hidden, treasure-filled valley, where people live wise, peaceful, and long lives. But to deem that Shangri La exists on a physical plane, as the Chinese have done, rather than simply on the pages of a book, is a wild stretch of the commercial mind. Nonetheless, the idea has a universal resonance—Hilton's book was translated into dozens of languages and made into a Hollywood film, and his phrase "Shangri La" entered the lexicon of English-speaking society right alongside Thomas More's "Utopia" to describe an Earth-bound paradise. The Chinese now seek to capitalize on that fascination and have appropriated the mental appellation to denote a real place on the planet.

The Chinese authorities first pinpointed the location of Shangri La in 1997. It must have been quite a feat considering the absence of cartographic coordinates. A geographer employed by the Tibet Tourism Bureau, in Zhongdian, determined the landscape around the upper gorges of the Yangtze River to be the heart of Shangri La—according to the Chinese, the "City of sun and moon in my heart." His leap-of-faith pronouncement was hailed by planners as a godsend. It provided them with an entirely new spin on the place: promote it as a geographical frontier for people desiring to travel not only to the very ends of Earth but beyond, into the geographical imagination.

Shangri La is promoted most heavily as a tourism destination among affluent people living on China's eastern coast—in cities such as Shanghai, Beijing, and Hong Kong—who seek relief from the relentless pace of urban life but who probably have never read James Hilton's book. For them, Shangri La exists only because of the tourism promotions. Many of China's younger populace, looking past the official propaganda, see Tibet and the Tibetans much as many North Americans understand their native cultures of that continent: as remnants of a romantic past and detached from the tumultuous present. In China's case, the tourism authorities take pains to portray the Khampa as the original inhabitants of Shangri La, thus promoting the idea of the place beyond its geographical attributes to include a mythologized culture. It's been a fairly successful campaign. Each year more Chinese tourists visit eastern Tibet, where they are promised nothing less than a paradise. Here, among the yak herds, nomads, and wildflowers, Shangri La finds its commercial home.

That the Chinese had the audacity to locate Shangri La in their territory displays the kind of unbridled capitalism with which modern China is enamored. In renaming parts of Tibet "Shangri La," they've foisted onto it an entirely new identity with great economic prospects, marked it with signboards, and developed full-blown tours to it—promoting them as journeys into a land of bliss. The Tibetan people of Kham and the Naxi tribes of Yunnan suddenly find themselves the inhabitants and protectors of a marketer's dream, just as the real places—monasteries, agricultural villages, grazing lands, and sacred spots of antiquity—are seized, renovated, and re-tooled for the upcoming tourist trade. The Chinese occupation of Tibet may have begun with military adventurism, but it continues by way of commerce.

In the midst of this tourism onslaught, the ruined monasteries are being refurbished or built new from the ground up, entire towns are relocated and renovated to replicate an historical era, and entry fees are charged for visiting the important historical sites. Ancient places with deep cultural roots are transformed into commodities for tourism. And the campaign isn't limited to the cultural landscape. The world-renowned biological diversity of the eastern Himalaya and its topographical centerpieces also are developed for tourism: lush gorges and mountain peaks are spanned with cable cars and bungee-jumping platforms, biologically rich forests are opened to backpackers and horse handlers with new trails and lodges, and resorts are built on the moraines of glacial lakes. Ironically, such changes forever remove these places from the wild or sacred. And, furthermore, the promotion of a literal Shangri La threatens the natural beauty of the region and the hope of its indigenous people to live an autonomous life. Such a process speeds the transformation of sacred Tibet into a secular world, thus violating the very heart of the idea.

I was drawn to the region like many others—partly because of its claim to Shangri La, but also because of its renowned geographical qualities. I wanted to observe how a mythological place might be constructed physically in the landscape. I'd been familiar with James Hilton's story of Shangri La from my boyhood reading—indeed, it was influential in the development of my own mental images of the world. And my later geographical studies in the Himalaya raised for me some questions about sacred landscapes and tourism that seem to have a bearing on what was happening in eastern Tibet.

I wanted to see the transformation for myself, so I bought a bus ticket in Kunming for Gyelteng, an old Tibetan town on the edge of the Tibetan Plateau that the Chinese had initially renamed Zhongdian, when they laid first claim to the territory, and then, more recently, Shangri La. The town is the official gateway into the realm of Shangri La and is loaded with tourism services; with its new name has come a new purpose. Waiting in the lobby of the bus station for my departure, I examined my ticket and noticed it was stamped "Destination: Shangri La" and thought it ironic that a place straddling the divide between imaginary and real worlds should be so simply and practically rendered. Supernatural attributes aside, the Chinese have made it merely a matter of logistics to enter paradise.

I rented a jeep and hired a driver in Gyeltang in order to see Shangri La. The itinerary was designed to allow access to as much of the place as possible in three weeks, to reconnoiter paradise out the window of a passing vehicle. It was a rough trip, despite the Chinese claims to the contrary. It rained a lot, with hail and snow squalls at the high altitudes. The roads often churned with mud. A friend joined me, and we spent nights in shabby way stations frequented by truck drivers. The smoky interiors of these small inns, lit by charcoal cooking fires, were filled with people hacking and spitting and chain-smoking through the nights. The mornings invariably dawned cold and cloudy. The days amounted to long slogs on bad roads, with detours to old monasteries or notable scenic features. But many of these places were fabulous, and those discoveries offset the miserable traveling conditions.

We crossed the Trola Mountains atop the "Winding Mountain Path" to arrive at a glacial lake located below the pass at 4,110 meters (13,484 feet) elevation. It appears under the name Yilhun Lhatso in the Buddhist literature and is a destination for Tibetan pilgrims. It was a fine day when we left our driver, Norbu, to trek up to the lake, but the weather quickly deteriorated, and we barely had time to make camp before a storm blew in. For the next hour it rained and hailed with vengeance, and gale-force winds threatened to blow the camp apart. It was all I could do to huddle inside my tent and hold its aluminum poles together against the force of the storm. The wind flattened the fabric against my body, and I could feel the hail pummel my skin.

When the storm passed and the rain lessened, I peered onto a surreal scene: the hail had painted the ground with a ghostly white color, and black evanescent clouds hung angrily above the lake, swirling in layers that rotated maddeningly in the sky. The water in the lake turned green and started to glow as if lit from deep within. The sky opened sufficiently to the west to allow the setting sun through, its rays striking the lake in a wash of light the color of blood, silhouetting a chorten that stood on a ridge above the lake. The religious structure cast its pyramid shadow on the roiling surface of the water.

Our tents were pitched on a boulder-strewn moraine. Now I saw that the rocks were all carved in a cursive Tibetan script. Hundreds of them, some larger than a house, had been sculpted into Buddhist prayer monuments, each with a religious passage chiseled onto their face. They protruded from the hill

like Moses's tablets in the Old Testament. The carvings were done with obvious reverence and an artistic flair, and they must have consumed much of the life of several persons.

These sculpted rocks, called *mani* stones, are common in the Buddhist Himalaya and often are found along walkways into villages or stacked at the base of a temple, but I had never seen them so large or so many concentrated in a single spot. My friend walked over from his tent, and together we marveled at the scene around us, taking in the scale of the place—not just the countless number of carved stones, but also the stunning backdrop of the lake and mountains and stormy sky. We both felt we'd stumbled upon a very special spot.

Shaken from the intensity of the storm and entranced by the exquisite post-storm light, we slowly got our bearings and examined more closely the monuments around us, playing a game of hide-and-seek among the giant mani stones, searching for specific scriptural passages or noting the minute details that were painstakingly carved into them, until it became too dark to see. We ended our walk at the lake and noticed several carved stones in the water, rising from its surface as if they, too, were floating prophetic tablets.

The evening turned clear and star-filled when it was time to sleep, and the night passed uneventfully. The following day broke sunny with a light frost on the ground. Things appeared different in the morning light. Normal. The sky was clear, and the mountain above the lake shined in the dawn, exposing a glistening white wilderness of glaciers and snowfields. The surface of the lake was still and reflected the scenery with all the resolution of a fine photograph. The mani stones had lost a certain luminosity given to them by the storm-light. And the lake, though lovely, was a fairly typical alpine tarn. Overall, the new sense of commonness that projected itself upon the scene was unsettling.

I think the transformation works like this:

The lake is revered by Tibetans and is believed to have a magical eminency, a place of power and pilgrimage, and it was this spiritual quality that manifested itself strongly on the previous evening. The storm had put us in a proper frame of mind to accept the transcendent quality of the lake, or at least its possibility. Such a realization need not require an epiphany or a specialized religious attitude. Like most sacred places, the lake had earned its

sanctity. The faith and practice of the Buddhists who visit its shores make it a holy place.

That morning we no longer had the place to ourselves. The tourists driven away from the storm had returned. A group from Beijing was climbing all over the place. Lingering playfully at the lake's edge, or propped against the chorten, or straddling a mani stone, many of them had expensive digital SLR cameras and speedily clicked away at one another with the lake in the morning light as a backdrop. The religious features became decorative props in these impromptu photo shoots. I learned that the tourists had read about the lake in the new edition of a popular travel guidebook and knew it by its Chinese name—Xinluihai Lake.

It's hard to put a finger on the experience. The scenery was made no less picturesque by the presence of the tour group, but it lacked the tactile quality and power of the night before. It could be put down as a psychological effect—an aversion to crowds. Looked at another way, an actual change had occurred in the energy of the place. For one, a passing meteorological event had changed the electrical charge in the atmosphere. But it was also more than that.

For centuries the lake has been visited by Buddhist pilgrims, for whom it represents the center of their cosmic map of the world. This sacred cartogram—called a *mandala*, with Yilhun Lhatso at its center—organizes the landscape into geometric structures that mirror the contemplative chambers of meditation. Such a configuration is emblematic of balance and equanimity— the prerequisites for a Buddhist's proper state of mind. The pilgrims who visit the lake with this belief in mind acknowledge its spiritual qualities and mark it with sacred symbols. The tourists, meanwhile, visit the lake to enjoy its scenic value—it's considered to be one of the most beautiful lakes in Tibet. The tourists arrive at the place consciously different from the pilgrims and leave behind a different set of marks on the lake—ones of recreation rather than of spiritual pursuits.

That morning we noticed things we had missed in the storm: a trail leading up from a parking area, where a gatehouse stood and an admission was charged to enter the lake; picnickers with blankets and food baskets at the lakeshore on a day of leisure; photographers stalking the scenery on both sides of the lake; a viewing platform jutting out from the bank below the chorten;

and candy wrappers and empty soda cans littering the ground. When the lake appeared on the tourist maps, it became another destination in the land of Shangri La and, perhaps, another casualty of it. I was grateful for the storm; while it raged, it had sufficiently erased the signs of modernity such that we could recognize the lake's otherworldly possibilities.

The Chinese campaign to shape a tourist paradise out of the mountains of Kham utilizes the natural qualities of a place and inevitably pulls at the spiritual traditions of its inhabitants. Yihun Lhatso is an example of this; its very sanctity, built over the ages, had put it into the guidebooks, and, as a result, it has become yet another roadside attraction. Many other examples exist in the region—forest groves, snow summits, temples, gorges, and waterfalls—which, by virtue of their sacred assignation or unique scenic qualities, now have a tourism value.

In James Hilton's book, the monastery of Shangri La is overlooked by a huge, white conical peak called Karakul. The mountain shimmers in the novel as a beacon of light. The equivalent mountain in the Chinese creation of Shangri La is 6,740-meter (22,113-feet) Kawa Karpa (also called Kawagebo). It shines above the trading town of Dechen in northern Yunnan province. It's not a bad topographic choice for a literary feature. Kawa Karpa sits dramatically above the Yubeng Valley as a silver peak, with glaciers hanging off it like icing on a cake. The Tibetans hold the mountain to be one of the most sacred in the world and circumambulate it on rigorous pilgrimages that may take a week or more to complete.

The easiest way to get to Kawa Karpa nowadays is to take the bus from Zhongdian (aka Shangri La) via the town of Dechen. The journey takes only a few hours and is easily arranged in Zhongdian, where it's promoted by the Tibet Tourism Bureau as one of the region's main attractions. Dechen, itself, lies in a deep valley, but the road beyond it leads to a prominent ridge that provides excellent spots from which to view Kawa Karpa.

The best vantage point is above an old monastery called Namka Tashi Lhakhang. Most tour buses and rental mini-vans shuttle people straightaway to this viewpoint, without stopping at the monastery, and park atop a ridge in a closed area. The parking spot was already full when I reached there. Tourists lined the viewpoint with a battery of photography equipment. Exclamations of "Shangri La" frequently came from the crowd, whose pronunciation ren-

dered it "Shangareela." A row of white chortens, newly built by the tourism authorities, framed Kawa Karpa nicely for the photographers.

Several guest houses stood opposite the ridge. They were constructed soon after the mountain had made it onto the Shangri La map. I walked into one of them, the "Snowy Mountain Guesthouse," and sat down at a table in its restaurant. The menu featured Shanghai bistro items and gourmet coffees. Across the room was an Internet station and beyond that an entertainment room for VCR and television. The proprietor told me that most people watch the 1937 movie *Lost Horizon*, starring Ronald Coleman, which is dubbed in Chinese in the guesthouse edition. The second most popular video in the house is a documentary film about some Japanese mountain climbers, who had attempted to climb Kawa Karpa but met with death before reaching the summit. The mountain remains one of the few famous Himalayan peaks never to have been climbed.

Karakul appears in Hilton's book as a signature mountain, and Kawa Karpa bears an uncanny resemblance to it, but he had sprinkled his Shangri La with numerous other geographical features as well—verdant valleys and gorges, forests and caverns, and misty waterfalls. Thanks to the diligence of the tourism authorities, these, too, have their literal equivalents on the Shangri La map: the sacred waterfalls in the Yubeng Valley, which are a popular destination for trekkers, the fantastic defiles of the Shangri La Gorge, Chitu Fairy Cave, an island in Bitu Lake, and Jade Dragon Snow Mountain, where a cable car puts people within easy reach of its snowfields and alpine meadows.

The southern boundary of Shangri La, in fact, is defined by the Jade Dragon Snow Mountain—a topographic grab-bag of thirteen snow peaks towering above the ancient Naxi town of Lijiang. The highest of them is the glaciated 5,600-meter (18,373-feet) Shanzidou Peak. It looks down upon dozens of other places that appear on the map of Shangri La: Black Dragon Pool, Lamps-of-the-Night-Bazaars, Lugu Lake, Stone Town, Bridge-Veiled-in-Mist-and-Willow-Trees, stone bridges, and many more. The spot I was most interested in visiting was called the "Map of the Sacred Road."

Roads enjoy quite a reputation in Shangri la. The region lies astride the ancient "Tea and Horse Caravan Road," which links the tea-growing regions of Yunnan with marketplaces in Tibet. Historians date the tea trade along this route to the Tang dynasty (C.E. 618–907), when the Lhasa aristoc-

racy began drinking tea and trading mountain horses for it. Fabulous tales of the road—bandits, immensely wealthy caravans, snow-bound passes and ice storms, burning sun, quicksand, trickery, and brave deeds—dominate the folk histories of this area and continue to pepper the tourist lore.

In World War II, the Tea and Horse Caravan Road became the main artery from India through Burma and into China, with more than 1,200 trading firms positioned along it to handle the volume of trade and war goods. Some of the old towns and way stations on the road, notably the picturesque canal town of Lijiang, are important enough to be designated as World Heritage Sites, although the actual caravan route is largely bypassed today with modern highways.

The Tibetans hold sections of the road to be sacred, part of a complex network of pilgrimage routes stretching across the Tibetan plateau. It is regularly traversed by Buddhist devotees journeying to Lhasa, some by way of prostrations—genuflecting and pulling themselves along the dusty road for a distance of more than 2,000 kilometers, (1,200 miles). I've observed them moving along in this way, wearing knee and hand pads against the hard ground, chanting with closed eyes, often accompanied by a spouse or helper hauling a handcart filled with belongings, and couldn't imagine me doing such a thing.

The strange juxtaposition of commerce and religion along the Tea and Horse Caravan Road, witnessed nowadays in the bowed pilgrims advancing serenely through clouds of diesel exhaust from a cargo truck speeding by, brings the past into the curious present. I was most interested, though, in a road that had nothing to do with traffic or linear distance. The "Map of the Sacred Road" was a funereal map of the ancient Dongpa religion, still practiced by some of the local Naxi people, showing the way not only to Lhasa, but also to personal redemption. The road requires passing through a demonic world of treachery and temptation. The "Map of the Sacred Road" was a map of the road from life to death.

I'd seen pictures of it in a tourism office in the Lijiang square and asked some townsmen if they knew anything about it. No one could identify the road—not even the workers at the Tibet Tourism Bureau, even when I showed them its picture, which appears in the official brochure published by their office. In the end, I happened upon a bus driver, whose route took him

in the direction of the Jade Dragon Snow Mountain, and he recalled seeing a signboard for a sacred road near an amusement park the Chinese authorities had recently built at the base of the mountain. He agreed to take me there for a modest fee.

The highway leading to the "Map of the Sacred Road" followed the willow-lined canals and cobblestone walkways of old Lijiang. It then passed sacred springs and a temple before diverting across the valley floor to the empty plains beneath the Jade Dragon Snow Mountain. We crossed the valley and turned toward a line of foothills, where I saw a human-made forest of oddly carved wooden statues. When we got close, I made out the individual totems, each representing a deity or demon: together, a spirit grove. Animal faces and elongated serpent bodies, some of them six meters (twenty feet) in height, lined the hill in a bizarre spectacle. The new assemblage was meant to connote, I supposed, a cultural relic, but it left the annoying impression of mere contrivance.

I left the vehicle at a turn-around and walked to a walled enclosure at the base of the totem forest. The path led to a small cubicle, where a uniformed guard collected an entrance fee. Past the gatehouse and across a stone courtyard was a terrace of rock and then more wooden statues beneath a threshold proclaiming, "Welcome to the Sacred Road." Ahead of me was a half-kilometer-long (one-third mile) pathway of decorative murals and carved rock-like outcroppings—the sacred road. It, too, was brand new and freshly painted in gaudy colors.

The sacred road snaked up the hillside and was flanked by a staircase of grotesque human-like forms and imaginary creatures. It was set amid a landscape crudely rendered in cement-sculpted mountains and forest trees and waving lines of blue to represent rivers. The carvings and paintings were interspersed with the cryptic hieroglyphic script of the Naxi people. I couldn't make any sense out of it. At the base of the staircase was a meditation platform in the shape of a large T'ai Chi symbol. Seated on a bench beside the platform was a man dressed as a Dongpa shaman: feathers and colorful banners showed beneath his conical black hat, and he wore a robe made of a patchwork of colorful silk fabric.

The man held a long spear in one hand and prayer bells in the other. He asked me if I wanted him to dance, and, though I deferred, he stood and

struck a curious pose with one foot in the air and both arms out-stretched, anticipating that I would take his picture. I ignored the man and proceeded up the road to the top of the hill, where a cluster of buildings stood against the white backdrop of the Jade Dragon Snow Mountain. The lower staircase had 108 steps, an auspicious number in Asia, and led to a second meditation platform that overlooked the lower road, the entrance gate, and the highway leading into town. Beyond the platform, the land leveled out atop the ridge.

The shaman walked up the road toward me. I continue onward, almost fleeing, through a human-made grotto of limestone pieces held together with concrete to resemble a cliff face and then into a small settlement of log cabins. The compound looked lived-in but empty. There was no option but to return the way I had come. At that point the shaman—or the guy dressed up as one—caught up with me and motioned that I should sit with him on a bench outside one of the buildings. It turned out to be his home. He offered me a cigarette. It was late in the afternoon and the end of his work day.

It was a strange place, this "Map of the Sacred Road." Aside from the shaman and the ticket-taker, I was the only person on the premises. The parking lot was empty, not a single tour bus was in sight, and the souvenir stalls that lined the entrance were closed and had an abandoned look to them. I asked the man in the shaman outfit what he did there. He replied in broken English that he was a priest in a nearby village. Rarely needed anymore by his own people, he'd hired himself out to the Tibet Tourism Bureau to guide tourists up the "Map of the Sacred Road." He said it was a regular paycheck.

I asked him about the staircase, which struck me as juvenile in its design and construction, like a hurried grade-school project in surrealism in Western art. He explained that the road map was new and built strictly for tourists, but an actual map of the sacred road exists and is very old. The authentic map is a banner that is displayed on auspicious days at the spot where the staircase had been built, and it was intended for religious devotion. He didn't know for certain where the old banner was being stored but thought, perhaps, in a museum in Lijiang or maybe in Kunming. He said the tourism authorities decided that a more durable road was needed to handle the crowds who would walk on it, so they built one—thus enshrining a metaphysical journey in concrete and a bad paint job. The tourists hadn't yet materialized, which was why the road was so new-looking: it was hardly scuffed by human feet.

I sat with the man for an hour or so, talking about the Dongpa religion, about which I knew nothing. It stems from the pre-Buddhist traditions of ancient Tibet. I came to realize slowly that the man was not a charlatan after all but an actual shaman. He showed me a number of ritual objects he kept in a closet in his house and explained how he used them during traditional ceremonies. The man came from a long line of priests in Lijiang. He occasionally worked for the Dongpa Culture Research Institute in Lijiang, which seeks to preserve the Naxi religion, but said that, for the most part, his life now had been reduced to guiding tourists rather than Naxi souls. When I asked him what he thought about the new Shangri La, the man kept silent but turned toward the summit of the Jade Dragon Snow Mountain, with a gaze that seemed to look out upon a much older place and time.

Situated on a ridge known as Guardian Hill about seven kilometers (four and one-third miles) north of Gyeltang is the Sungtseling Monastery, the largest Buddhist complex in Shangri La. It houses 700 monks and contains dozens of assembly halls and meditation chambers. Galleries holding the statues of saints lined the hallways. The Sungtseling Monastery is the tangible version of the Shangri La temple that figures so prominently in James Hilton's book. It was built in 1681 as a center for Buddhist study. Much of the monastery was destroyed during the Cultural Revolution and is being renovated and expanded with the commercial promotions of Shangri La. It's the most important attraction in the prefecture.

I caught a morning bus from the old quarters of Gyeltang to a small village located at the base of the monastery, hopping out before we reached the settlement to walk over to where some women were working in a barley field. They bent low at the waist to cut handfuls of grain with steady, rhythmic swings of their sickles, unmindful of me. Beyond the workers, across the field, was the Sungtseling Monastery, rising in majestic relief against the Guardian Hill. It made an impressive sight: the mammoth red complex crowned a pyramid of smaller structures, each house in turn resting atop others, all of them flowing down the slope in a cascade of ochre-and-white houses that dropped like building blocks onto the surrounding grain fields. The morning sun lit the monastery, while the hill behind remained in dark shadow, so that the temple fairly glowed. The roofs were gold and capped with thunderbolts,

mythic animals, and lightening. The icons sprouted from the buildings like glistening spurs of jewelry.

I climbed a flight of stairs to the monastery's entrance. It was early. Few people were about: a couple of monks were sweeping the courtyard, and an elderly woman watered a few potted plants. A sign on the ticket booth announced a ten-Yuan admission fee, but it hadn't yet opened for the day, so I walked freely into the complex. I came upon a large flagstone plaza fronting onto the main assembly hall. A set of imposing wooden doors, embellished with bronze handles and protector medallions that the monks had salvaged from the wreckage of the original monastery, marked the entrance to the building. A drapery of black-and-white cotton stitched in geometric patterns hung over the doors.

After a short time, a monk appeared and opened the monastery, disclosing a room decorated in frescos that depicted the monastery's lineage of reincarnate lamas and pantheon of protector deities and living saints known as *bodhisattvas*. From deeper within the assembly hall came the cacophonous music of morning prayers—chanting, drums, and clanging cymbals. I sought out the sound, which took me up a rickety set of stairs to a gallery overlooking the main hall and beyond that into a small meditation chamber, where two monks draped in burgundy robes sat on woolen carpets opposite one another. They read aloud from wood block prayer books, clanged cymbals, and hammered on a gong—the vibrations filled the room. A single cracked window let in sunlight. The intermingled scent of sandalwood, butter lamps, and musty old books drifted through the chamber. I sat for awhile in silence, enjoying the moment, letting my mind go blank.

After some time, I heard noises outside and made my way back to the courtyard, where I found several tour groups recently arrived from Gyeltang. The leaders of the groups waved yellow flags, and the tour members wore colorful baseball caps. There was a yellow-hat tour, a red-hat tour, and a blue-hat tour—like religious sects. The arrivals were breathing hard after the steep climb up from the village. After a spirited introduction to the place by their leader—more like a pep rally—the tourists split up to explore the monastery on their own. A few of them sauntered over to a set of wooden stairs and sat down and smoked cigarettes, while others clambered about the place—crossing thresholds or climbing over walls, squeezing between chambers, examin-

ing the colorful wall paintings, spinning prayer wheels, or taking photographs, which were permitted.

Prior to Chinese rule in Tibet, the local villagers were responsible for the upkeep of monasteries in exchange for spiritual guidance from the resident lamas and monks. This was true for the Sungtseling Monastery as it was for all the Tibetan temples. Nowadays, though, the revenue from tourism mainly rebuilds the ancient monuments and the primary purpose is to make them attractive for visitors. The new designs, incorporating Han elements as well as traditional Tibetan ones, showcase an incongruous mixture of religious art drawn from cultural traditions all across Asia. The result is a discordant blend of old and new—the salvaged remains of ancient, bombed-out monasteries competing with the designs of modern tourism.

I left Sungtseling Monastery with mixed thoughts. It's a magnificent structure, and the renovations will make it even more beautiful, but it was missing a piece of its soul—a loss of heritage. The reverence I felt inside many of the old monasteries in the Himalaya was absent, or much diluted, in the Sungtseling Monastery. The renovations had a shiny new look, but it was only paint-thin—a veneer that might easily wash away amid skepticism or ignorance. Even the bright new statues of Buddha lacked authenticity, when they incorporated the stylistic touches of foreign civilizations. The most important temples in Tibet were destroyed during the Cultural Revolution, and it's important that some of them are rebuilt, but many of the modern restorations create amusements pieces for tourists rather than places of true spiritual practice.

My thoughts about Sungtseling Monastery reinforced a sinking feeling I had about the prospects of Shangri La: it seemed a sham. Of course, only so much can be expected when a mythical paradise is carved out of an earthly realm. The Tibetan Plateau, the mountains of Yunnan, and the deep gorges of the region invite superlatives because they truly are spectacular places. Their fabricated historical character, however, meant simply to attract commerce, is distracting and unnecessary, and it does actual harm: it diverts attention away from the spirit of a place as it guides visitors toward recreation. Meanwhile, the people who live in the middle of the map of Shangri La, the Tibetans and Naxi, confront a similar fabrication of culture but to even more egregious effect: the risk of producing a hollow identity.

One evening, when I was back in Gyeltang, I witnessed an event that suggested I was wrong in some of my thinking about the artificiality of Shangri La. In the center of the old town, where renovations are underway to create new inns and handicraft shops, is a large, stone-paved square, where the Tibetans traditionally held community dances. During the tourism season, dances are put on for the entertainment of visitors. The dancers stand in huge circles, hand-in-hand, and sing folk tunes and kick their legs back and forth in a manner not unlike a North American country-and-western line dance. Always, there is much laughter and horsing around.

That evening I watched a few tourists tentatively join the Tibetan dancers and then more of them, until half the dancers in the circle were Han Chinese. The tourists didn't know the steps of the dances, but their Tibetan partners patiently showed them the right moves. It took awhile for many of them to catch on—the dances mimicked the movements of yak and the postures of Khampa horse riders. At first, I thought the tourists had entered the dance simply because it was expected of them—part of the tour, like karaoke—but I saw that they soon gave themselves over to the dance and, in doing so, came under the spell of the Tibetans.

Surprisingly, the sight of the dancers affected me deeply—the Chinese and Tibetans were holding hands together and dancing and laughing at one another's foolishness. It gave an advertant sense of hope to the place, as if the promise of Shangri La might be realized after all. The Chinese tourists come to this region because they've been lured by the tourism promotions that advertise it as Shangri La. Perhaps they seek respite from their techno-urban worlds in Beijing or Shanghai or Hong Kong, who knows? Perhaps they come to find, at least in their imagination, a land of beauty and hope and goodness. Inevitably, they discover more about Tibet, which they know only from the propaganda literature published by the Chinese authorities, and that, I imagine is a good thing. That they might also actually find beauty and hope and goodness, though, is what I saw reflected in their faces as they laughed and danced with the Tibetans in Gyeltang.

ENCOUNTERS WITH THE HIMALAYA

(Himalaya: 1975–2010)

WHEN I REFLECT UPON THE DECADES I have spent in the Himalaya, I note a corresponding synchronicity between two encounters: the changes that have actually occurred there and the influence that my own experiences and traverses in these highest of Earth's mountains have had on me. The coupling of these events I liken to a great turning, the fulcrum of which is a matter of perspective.

My view of the Himalaya has surely deepened, even as the place itself undergoes transformation, because I have a memory of it all and have been shaped by it. This projection undeniably personifies that which I initially sought to observe in a scientific way. And while my geographical studies have explicitly considered the nature of flux in Himalayan places, I have been slow to acknowledge that the most important changes all the while were those occurring within me. Not only had I gained a scholarly perspective, but my life was opened to new ways of apprehending the world.

Not all the places in the Himalaya are equally affected by the changes. It is a vast region. When I first explored the western end of the Himalaya during the mid-1970s, my journeys took me through the Karakoram Range in Pakistan. While I didn't include those sojourns in these essays, I acknowledge the range to be an important extension of the Himalaya. Indeed, geographers may conflate the two in a grand geological and cultural synthesis of the South Asian rim and its lands. Nestled within the Karakoram Range are some truly remarkable places, among them the Chitral Valley and its offshoot tributary valleys, which host the few surviving members of the Kailash tribes; the engineering marvel that is the Karakoram Highway; the lovely Swat Valley, where insurgents now rule amid violence; and five of the world's fourteen

peaks above 8,000 meters (26,246 feet), including Earth's second-highest summit—K-2 at 8,612 meters (28,255 feet).

The Karakoram Range is inhabited mainly by Islamic peoples. The cultural linkages here extend to the west, to Afghanistan and the Hindu Kush Range, rather than eastward into the Hindu and Buddhist realms of the Himalaya. Such western connections date to Moghul times and earlier, when Muslims migrated to the area for purposes of conquest, agriculture, and trade. The tribes of the Karakoram converted to Islam. East and south of the Karakoram Range, across the Indus River, a zone of cultural convergence occurs in Ladakh and Zanzkar, where Islamic and Buddhist peoples intermingle among the cosmopolitan trading towns and in the rural farming villages. Such a coming-together of faiths and civilization is not only evident in architecture, art, and settlement patterns, but is also reflected in the cultural complexion of the western axis of the Himalaya.

I chose to emphasize the geological qualities of Ladakh and Zanzkar in this book, but the place is equally fascinating for its cultural heritage. This high and arid country shares a great deal in common with neighboring Tibet, but the influences of Islamic civilization also are strongly evident in the landscape. Perhaps nowhere is this more telling than among the eleventh-century ruins at Alchi in Ladakh. Here, amid the crumbling stone chortens and deteriorating monastery facades, I found a remarkable set of interior frescos depicting the story of Buddhism painted in the Islamic style of Kashmir. I spent long hours with a flashlight inside the ancient chorten temples, trying to make sense out of the magnificent and highly detailed paintings. In the end, I was content to let the tableau, in its entirety, move me rather than attempt a logical deciphering of the individual pieces.

Muslim traders historically controlled the mercantile centers along the Indus River, and even today, in places such as Leh and Kargil, their mark on the landscape is readily observed in mosques, trading houses, and languages. I stayed in Leh with a Muslim family descended from the earliest Islamic traders working the Indus Valley, and the head of the household regaled me in the evenings over meals of tea and flatbread with the long and convoluted history of his family. He sought to continue the family tradition of inn-keeping but with an eye now to the new foreign tourists in addition to the old Silk Road traders.

South of Zanzkar and adjoining provinces of Spiti and Lahaul, the terrain, climate, and culture all change precipitously toward the Baspa Valley. The high crest of the Himalaya has been crossed so that the summer monsoon extends its moist reach here. The result is a greener, productive, and more densely settled place. Here, one has entered the Hindu world with its temples and deities, societal norms and vernacular architecture, rice farmers and sadhus, mendicants and caste workers. The historical trajectory of Hindu culture is southward to India rather than west to Central Asia (as is the case with the Karakoram Islamists) or north to Tibet (for the Buddhists in Ladakh and Zanzkar). From the Baspa Valley and adjoining districts in India, Hindu society extends across the middle mountains of Nepal to Bhutan, forging the Himalaya's most expansive cultural realm—and one of the most densely settled swaths of mountain farmland in the world.

Hinduism and Buddhism converge most pointedly in Kathmandu, where the landscape displays an eccentric mixture of the faiths and deities are shared among the respective faithful. For newcomers to the city, the religious juxtapositions add to the secular confusion of the place, building upon the apparent urban chaos; they are a source of inspiration for some and bewilderment for others. After decades of exploring this maddening city, I still take great pleasure in discovering new places, where the diverse cultures co-exist, and in finding in their synthesis a fresh way of looking at the world.

Kathmandu is one of the great valleys of the Himalaya. Others include the Kashmir and Doon valleys in India, the Chumbi Valley in Sikkim, and the smaller but prominent Paro and Thimphu valleys in Bhutan. These valleys tend to be long-settled places and often are the historical centers of local civilization. In Bhutan, the midland valleys are settled predominantly by Buddhist peoples, who originate in Tibet, but historical migrations of Hindus hailing from Nepal have added to the cultural diversity of the kingdom—not always to a happy conclusion. Traveling eastward through Bhutan, the landscape shows signs of more localized affinities, and, by the time one enters the Indian state of Arunachal Pradesh, the native animistic societies prevail amid a polygot of tribal culture.

Environmentally, this eastern region of the Himalaya is wet, lush, and topographically diverse, anchored by 7,782-meter (25,532-feet) Namche Barwa, traversed by gorges, and politically contested by neighboring countries. It's one of the least explored sectors of the range. I've yet had the occa-

sion to visit this part of the Himalaya and know it only from what I've read and from what my friends and colleagues tell me about it—that it's one of the last great places in the world. Perhaps that sentiment exists because it is still largely unknown, and travel there is restricted by the border policies of India and China, thus adding to its allure for some adventurous foreigners.

North of Arunachal Pradesh, beyond the Himalayan crest and the great bend of the Tsangpo-Brahmaputra River and amid the plateaus and summits of eastern Tibet, is the province of Kham. For centuries, the nomadic Khampa have herded yak among the pastures, crossed the high mountains in trade caravans to barter salt in India, and attacked emissaries and traders traveling along the Tea and Horse Caravan Road. Nowadays, the Khampa are ruled by the Chinese, who have put considerable effort into developing this remote region for tourism—building facilities that make it easier to experience paradise.

When I traveled to eastern Tibet, drawn by its mystique as well as by the commercial ventures that are transforming it into a fake Shangri La, I found it to be utterly different from any other place I'd been in my journeys in the Himalaya. Of course, by that time, in Kham, I was at the extreme edge of the geographical Himalaya, and some would suggest I was no longer in the same range of mountains. Arguably, this is true, and I am responsible for occasionally blurring the cartographic boundaries to account for cultural attributes assigned to the region.

Early on, I thought the rugged terrain of the Himalaya would separate people and make cultural convergences there unlikely. I thought that isolated societies would prevail amid geographical circumspection. I imagined places in a state of acute separation. I have found just the opposite to be the case. The mountains are traversed by passes and caravan routes, valley trails and modern roads, and people are on the move today as much as they always have been. Mountain society is fluid and mobile, despite the mighty grain of the Himalaya, and this is precisely what has forged the cultural traits that give the range its exquisite human outlook.

My own peripatetic encounters with the Himalaya pale against the long history of travel in the region, and they are unique only insofar as they have influenced my geographical scholarship and imagination. As luck would have

it, and contrary to my early naive ambitions, I have become the main legacy of my time in the Himalaya. But that is one of the reasons for travel: to come to know not only a place, but also our self within the larger world.

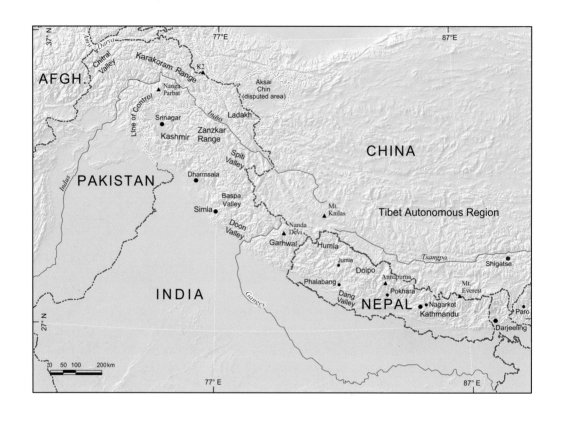

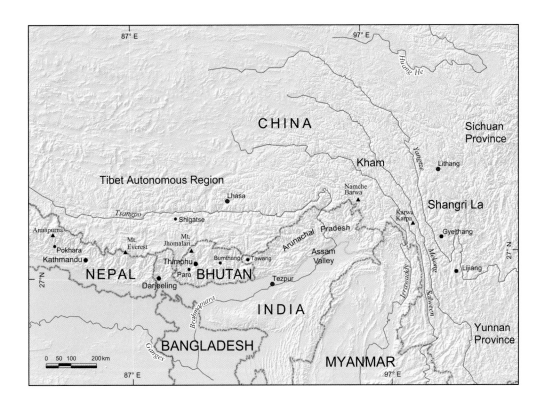

Aris, Michael, *The Raven Crown: The Origins of Buddhist Monarchy in Bhutan* (London: Serindia Publications, 2005).

Baker, Ian, *The Heart of the World: A Journey to Tibet's Lost Paradise* (New York: Penguin, reprint edition, 2006; originally published in 2004 by Penguin Press, of New York City).

Carpenter, Russ, and Blythe Carpenter, *The Blessings of Bhutan* (Honolulu: University of Hawaii Press, 2002).

Child, Greg, *Thin Air: Encounters in the Himalayas* (Seattle: Mountaineers Books, reprint edition, 1998; originally published in 1990 by Gibbs Smith, of Salt Lake City).

Coburn, Brot, *Himalaya: Personal Stories of Grandeur, Challenge, and Hope* (Washington, DC: National Geographic Society, 2006).

Jinpa, Gesha Gelek, Charles Ramble, and Carroll Dunham, with photographs by Thomas L. Kelly, *Sacred Landscape and Pilgrimage in Tibet: In Search of the Lost Kingdom of Bon* (New York: Abbeville Press, 2005).

Herzog, Maurice, *Annapurna: First Conquest of an 8,000-meter Peak* (Guilford, CT: The Lyons Press, reprint edition, 1997, and second edition, 2010; originally published in 1952 by E. P. Dutton, of New York City).

Hilton, James, *Lost Horizon* (New York: Harper Perennial, reprint edition, 2004; originally published in 1933 by Grosset and Dunlap, of New York City).

Ives, Jack, *Himalayan Perceptions* (London and New York: Routledge, 2004).

Karan, P. P., *Bhutan* (Lexington: University Press of Kentucky, 1967).

Keay, John, *The Great Arc: The Dramatic Tale of How India Was Mapped and Everest Was Named* (New York: Harper Perennial, 2001).

Laird, Thomas, *The Story of Tibet: Conversations with the Dalai Lama* (New York: Grove Press, 2006).

Lopez, Donald, *The Story of Buddhism: A Concise Guide to Its History and Teachings* (San Francisco: HarperOne, 2002, reprinted in 2007; originally published in 2001 by HarperOne, of San Francisco).

Mason, Kenneth, *Abode of Snow* (Seattle: Mountaineers Books, reprinted in 1987; originally published in 1955 by E. P. Dutton, of New York City).

Matthiessen, Peter, *The Snow Leopard* (New York: Penguin, reprint edition, 1987; originally published in 1978 by Viking Press, of New York City).

Mcrae, Michael, *The Siege of Shangri La: The Quest for Tibet's Sacred Hidden Paradise* (New York: Broadway Books, 2002).

Meyer, Kurt, with contributions by Pamela Deuel Meyer, *In the Shadow of the Himalayas: Tibet–Bhutan–Nepal–Sikkim, a Photographic Record by John Claude White, 1883–1908* (Ahmedabad: Mapin Publishers, 2006).

Palin, Michael, *Himalaya* (New York: Thomas Dunne Books, reprint edition, 2005; originally published in 2004 by Weidenfeld & Nicolson, of London).

Pommaret, Francoise, *Bhutan: Himalayan Mountain Kingdom*, 5th edition (Hong Kong: Odyssey Publications, 2006).

Schaller, George B., *Stones of Silence: Journeys in the Himalaya* (Chicago: University of Chicago Press, reprint edition, 1998; originally published in 1980 by Penguin Group, of New York City).

Shroder, John, *Himalaya to the Sea: Geology, Geomorphology, and the Quaternary* (London and New York: Routledge, 1993).

Stewart, Jules, *Spying for the Raj: The Pundits and the Mapping of the Himalaya* (Gloucestershire: Sutton Publishing, 2006).

Swan, Lawrence W., *Tales of the Himalaya: Adventures of a Naturalist* (La Crescenta, CA: Mountain N'Air Books, 2000).

Tuan, Yi-Fu, and Martha A Strawn, *Religion: From Place to Placelessness* (Chicago: The Center for American Places at Columbia College Chicago, 2009).

Valli, Eric, and Anne de Salles, *Himalaya* (New York: Harry N. Abrams, 2004).

Whelpton, John, *A History of Nepal* (Cambridge, UK: Cambridge University Press, 2005).

Zurick, David, and Julsun Pacheco, *Illustrated Atlas of the Himalaya* (Lexington: University Press of Kentucky, 2006).

Zurick, David, and P. P. Karan, *Himalaya: Life on the Edge of the World* (Baltimore and London: The John Hopkins University Press, in association with the Center for American Places, 1999).

N
O ONE TRAVELS in the Himalaya without the assistance of
many people. In my case, the following people provided me
with help, guidance, or companionship: Nigel Allan, Birendra Bajracharya,
Dilip Banerjee, Dinesh and Keshav Bhattarai, Gabriel Campbell, Ibrahim
Chapri, Mark Conley, Chris Deegan, Karma Dorji, Carroll Dunham, Tom
Fricke, Praveen Grover, Chandra Gurung, Don Bahadur Gurung, Harka
Gurung, Dilli Raj Joshi, Hari Kadel, Pradyumnan Karan, Dakpa Kelden,
Muhammad Ayaz Khan, Duane Kissick, Mani Lama, Shyam Tamang Lama,
Sumitra Manandhar, Donald Messerschmidt, Sam Mitchell, Chris Monson,
Marcia and Mac Odell, Craig Overly, Ram Panday, Prakash Pathak, Tsering
Phuntsok, Subash Rai, Dorje Rinchen, Chatral Rinpoche, ChoNyi Rinpoche,
Baikuntha Sharma, Basanta Shrestha, Rajendra Shrestha, Lobsang Tenzin, M.
P. Thakore, Chencho Tsering, Lu Yuan, Pralad Yonzon, Dawa Zangpo, and
Jennifer Zurick. I am grateful to them all and am sorry if I've left anyone out.

I am also grateful for the financial support I've received over the years
for my field work in the Himalaya. The following organizations deserve spe-
cial thanks: American Alpine Club, American Geographical Society, Banff
Centre, Eastern Kentucky University, East-West Center (Honolulu), and
National Science Foundation.

7-8; historical landmarks in, 8; infrastructure, 6; markets in, Fig. 4; pilgrims in, 11; political change/unrest in, 7, 17-18, Fig. 8; sacred places in, 13; sprawl in, 7-8, 15, 17; temples in, 4, 8, 10, 11, 19, Fig. 2

Kathmandu Valley, 3-20, 89; historical landmarks in, Fig. 11, 14; pottery in, Fig. 5; temples in, Fig. 10, 14, 15; world heritage site in, Fig. 11

Kawagebo: see Kawa Karpa, Mount

Kawa Karpa, Mount, 78-79, Fig. 64

Kham, x, 69-73, 74, 78, 90, Figs. 57, 62; ceremonial grounds in, 70; military invasion/occupation of, by Chinese, 70-71, 74; temples and monasteries in, 70, 76; trading posts in, 70

Khampa (people of Kham), 12, 70, 73, 86, 90; as "Gentlemen Brigands," 70; horse riders of, 86

Khumbu region, 6

Kibber, Fig. 26

Kinnaur Kailash Range, 21, 27

Kunming, 74, 82

Ladakh, ix, 26, 27, 31, 32, 88, 89, Figs. 30, 31

Ladakh Range, 27, 28

Lahaul, 88

Lama Chazampa, 63

Lamayuru Monastery, 30

Lamps-of-the-night Bazaars, 79; land, "sacred calculation" of, 10

Land of Swan, 66

"Land of Treasure Places," 52

Land productivity, 30, 47

Landscape features: alpine zone, ix, 25, 79; basins, 25; beauty of, 65; caves/caverns, 4, 12, 60, 79; deserts, ix, 5, 22, 27; footpaths, 30; gardens, 8; as a grand cosmologic cycle, 30; glacial lakes, 25, 74, 75, 76-78; glaciers, 13, 21, 23-26, 76, disappearance/melting of, in mountains, 23-25, 34, runoff from, 25, 30; gorges, 5, 14, 15, 22, 31-32, 67, 73, 74, 79, 85, 90; ice field, 24; jungles, 5; landslides/rockslides, 26, 38, 43, 44; meadows, alpine, 79; middle mountains, ix; moraines, 21, 22, 25, 74; mountains: see separate entries; night skies, 29; panoramas, 36; passes, mountain, 14, 27, 28, 33, 46, 67, 90, Fig. 20; pastures/pastureland, ix, 9, 21, 22, 24, 35, 67, Fig. 13; promontories, 22, rice paddles/fields/terraces, 4, 15, 35-36; as sacred/holy, 10, 30, 47, 57, 63, 74, Figs. 13, 63; changes in, 13, 36; cultural, 74; degradation of, 36; in Bhutan, 57-58; scenic views, 16; seabed, 26; seashells, 28; snowfields, 22, 76, 79; snow line, 15, 31; spirit grove, 81; tarns (alpine lakes), 25; treasure places: see separate entries; tree nurseries, 48; waterfalls, 78, 79; watersheds, 22, 37; wilderness, 67, 74, 76; manicured, 36; odors associated with, 7, 40, 43, 47, 55, 59; panoramic/scenic, 26, 69, 77,

Figs. 1, 16; photography, 56; sounds associated with, 20, 30, 35, 39, 40, 84; watercolors, as an image of, 36

Langtang Valley/Himal, 6, Fig. 1

Languages/dialects, 5-6, 8, 26, 48, 52, 53, 88

Leh, 88

Lhasa, 70, 71, 72, 80; aristocracy of, 80

Lijiang, 79-80, 81, 82, 83

Livestock, 44, 46, 67, 69, 70, Fig. 29

Livestock census, 44

Lodging, 8, 14, 17, 21, 43, 56, 59, 72, 74, 78, 79, 88-89, Fig. 36

Logging, 41-42

Losing Ground, 38

Lost Horizon, x-xi, 72, 73, 74, 78, 79, 83; the book, 51; the movie, 79

Lugu Lake, 79

Machig Labdoenma, 61

Magar tribes, 6, 46

Mahabharata, 12

Makalu, Mount, 3

Malaria, 42-43

Mandala, 30-31, 77

Manjushree, 16

Maoist insurgency, 17, 19

Map of the Sacred Road, 80-82

Maps: and imagery, xi

Markha Valley, 27

Meditation: see prayer

Mekong River, 70

Migration, xi, 5-6

Milarepa, 61

Minerals, 13

Mining, 42

Moghul times, 88

Monasteries, facades of, 4, 88; geographical setting of, 29-30; in Bhutan, 60-61, 67, Figs. 49, 56; in India, Fig. 31; in Kathmandu, 11; in Kham, 70, 73, 74; in Tibet, 73-75, 78, 83-85, Fig. 60; in Zanzkar, 29-30, 33, Fig. 23

Monks/priests, 11, 15, 30, 33, 35, 37, 39, 40, 43, 46, 59, 71, 82-84, Fig. 15, 31, 43, 60

Monsoon/rains/season, ix, 3, 15, 22, 26, 36-37, 46, 47, 54, 89, Figs. 3, 34, 35, 50; in Bhutan, 54, 55, 62, 65; in Tibet, 69

More, Thomas, x, 72

Motorbikes, Fig. 59

Mountains, and mountaineers, 34; as "high energy environments," 26; and spiritual solace, 13; climbing of, 34, 79; experience of, 14-15, 22, 24, 25, 28; sacredness of, 34, Fig. 13; scale of, 5

Mystery/mysticism, 14, 30, 63

Nagarkot, 14-15, 16-17

Nagarkot Road, Fig. 16

Namka Tashi Lhakhang, 78-79

Namche, Barwa, 89-90

Nanga Parbat, Mount, i

DAVID ZURICK was raised along the shores of Lake Huron in Michigan. He obtained his undergraduate and master's degrees in geography from Michigan State University and completed his Ph.D. in geography at the University of Hawaii. In 1987, he joined the faculty of Eastern Kentucky University, where he is Foundation Professor of Geography. Zurick has conducted geographic field studies and photographic surveys throughout the world since 1975. He is a two-time recipient of an Al Smith Visual Artist Fellowship from the Kentucky Arts Council, and his fieldwork has been supported by grants and awards from the National Science Foundation, the East-West Center in Honolulu, Banff Centre, and the American Alpine Club. In 1987, he was nominated a Fellow of the Explorers Club. Zurick is the author of *Hawaii, Naturally* (Wilderness Press, 1990); *Errant Journeys: Adventure Travel in a Modern Age* (University of Texas Press, 1995); *Himalaya: Life on the Edge of the World*, with P. P. Karan (The Johns Hopkins University Press, in association with the Center for American Places, 1999); *Illustrated Atlas of the Himalaya*, with Julsun Pacheco (University Press of Kentucky, 2006); and *Southern Crossings: Where Geography and Photography Meet* (The Center for American Places at Columbia College Chicago, 2010). In 2006, he won the National Outdoor Book Award, and he has twice been a finalist for the Banff Mountain Book Award. Zurick lives in a tributary valley among the foothills of the Cumberland Plateau near Berea, Kentucky.

ABOUT THE BOOK

———————————

The Himalaya: Encounters with the Roof of the World is the sixth volume in the Center Books on the International Scene series, George F. Thompson, series founder and director. *The Himalaya* was brought to publication in an edition of 1,000 hardcover copies. The text for was set in Requiem, the paper is Gold East Matte Art 128gsm weight for the text and 157gsm weight for the photographs, and the book was printed and bound in China. For more information about the Center for American Places at Columbia College Chicago, please see page 108.

FOR THE CENTER FOR AMERICAN PLACES
AT COLUMBIA COLLEGE CHICAGO:

George F. Thompson, *Founder and Director*
Susan Arritt, *Consulting Editor*
Brandy Savarese, *Editorial Director*
Jason Stauter, *Operations and Marketing Manager*
Erin F. Fearing, *Executive Assistant*
A. Lenore Lautigar, *Publishing Liaison and Assistant Editor*
Melissa L. Jones, *Editorial Assistant*
Purna Makaram, *Manuscript Editor*
David Skolkin, *Book Designer and Art Director*

Center for American Places

AT COLUMBIA COLLEGE CHICAGO

The Center for American Places at Columbia College Chicago is a nonprofit organization, founded in 1990 by George F. Thompson, whose educational mission is to enhance the public's understanding of, appreciation for, and affection for the places and spaces that surround us—whether urban, suburban, rural, or wild. Underpinning this mission is the belief that books provide an indispensable foundation for comprehending and caring for the places where we live, work, and commune. Books live. Books are gifts to civilization.

Since 1990 the Center for American Places at Columbia College Chicago has brought to publication more than 350 books under its own imprint and in association with numerous publishing partners. Center books have won or shared more than 100 editorial awards and citations, including multiple best-book honors in more than thirty fields of study.

For more information, please send inquiries to the Center for American Places at Columbia College Chicago, 600 South Michigan Avenue, Chicago, Illinois 60605–1996, U.S.A., or visit the Center's Website (www.americanplaces.org).